D0899180

W. E. B. Du Bois's
Exhibit of American Negroes

W. E. B. Du Bois's Exhibit of American Negroes

African Americans at the Beginning of the Twentieth Century

Eugene F. Provenzo Jr.

ROWMAN & LITTLEFIELD
Lanham • Boulder • New York • Toronto • Plymouth, UK

Published by Rowman & Littlefield
4501 Forbes Boulevard, Suite 200, Lanham, Maryland 20706
www.rowman.com

10 Thornbury Road, Plymouth PL6 7PP, United Kingdom

British Library Cataloguing in Publication Information Available

Library of Congress Cataloging-in-Publication Data

Provenzo, Eugene F.
 W. E. B. Du Bois's Exhibit of American Negroes : African-Americans at the
beginning of the twentieth century / Eugene F. Provenzo Jr.
 pages cm
 Includes bibliographical references and index.
 ISBN 978-1-4422-2393-6 (cloth : alk. paper)—ISBN 978-1-4422-2628-9 (electronic)
 1. Du Bois, W. E. B. (William Edward Burghardt), 1868–1963. Du Bois albums
of photographs of African-Americans in Georgia exhibited at the Paris Exposition
Universelle in 1900. 2. African-Americans—Georgia—Social conditions—
Exhibitions. 3. African-Americans—Georgia—Social life and customs—
Exhibitions. 4. African-Americans—Georgia—Social conditions—Pictorial
works. 5. African-Americans—Georgia—Social life and customs—Pictorial works.
6. Exposition universelle internationale de 1900 (Paris, France) I. Title.
 E185.53.P37P76 2013
 305.896'0730758—dc23 2013020130

∞™ The paper used in this publication meets the minimum requirements of American
National Standard for Information Sciences—Permanence of Paper for Printed Library
Materials, ANSI/NISO Z39.48-1992.
Printed in the United States of America

For Michael Carlebach,
in appreciation of his commitment to photography as a source of
historical understanding and for his work as a gifted teacher.

W. E.B. Du Bois's
Exhibit of American Negroes

Table of Contents

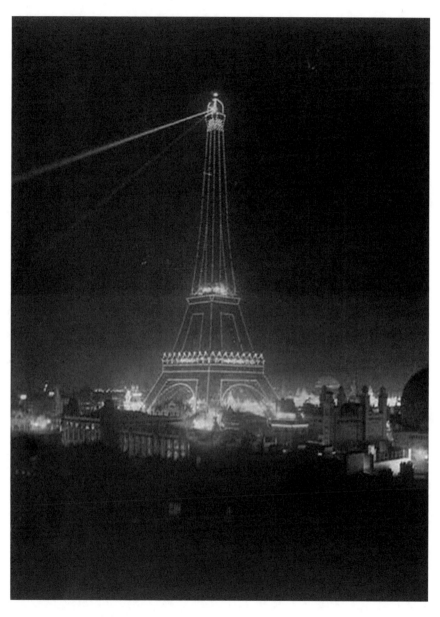

Eiffel Tower illuminated at Paris Exposition, 1900. Courtesy of the Library of Congress (Unless otherwise noted, all figures and illustrations included in this work are from the Library of Congress, Prints and Photographs Division.)

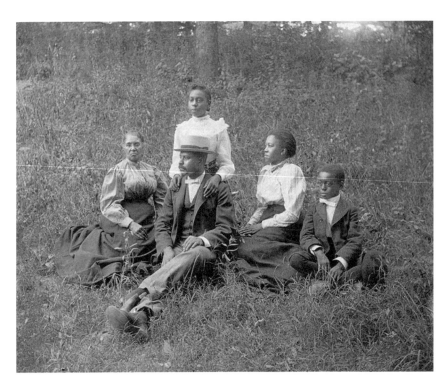

African-American family posed for portrait seated on lawn. Georgia Negro Exhibit, Exhibit of American Negroes, Paris 1900 Exposition.

Preface

This is a book about African-American culture and life at the beginning of the twentieth century. It draws on many different historical and sociological sources, and focuses in particular on the year 1900 and the Exhibit of American Negroes at the *Paris Exposition Universelle de 1900*.[1]

While the international expositions of the late nineteenth and early twentieth centuries were to a large extent concerned with business and industry, they also included displays of a social and cultural nature.[2] Anthropological and educational exhibits were particularly popular. Consistent with this tradition was the development of the Exhibit of American Negroes for the *1900 Paris Exposition Universelle*. The exhibit was initially the brainchild of the lawyer and educator Thomas J. Calloway.[3]

Thomas J. Calloway

In October 1899, Calloway wrote to over one-hundred Black leaders in the United States proposing that an exhibit representing the development of Negroes since Emancipation be sent to the 1900 Paris International Exposition. Calloway wished to overcome the misrepresentations of Blacks that were so common in American culture. By means of an exhibit of Negroes at the Paris Exposition, he felt that it would be possible to gain the attention of both Europeans and White Americans visiting the Fair. Calloway's plan was to create a carefully constructed exhibit describing the development of Black churches, schools, homes, farms, businesses and professions. As he explained in his October letter: "To the Paris Exposition…thousands upon thousands will go, and a well selected and prepared exhibit, representing the Negro's development of his churches, his schools, his homes, his farms, his stores, his professions and pursuits in general will attract attention as did the exhibits of Atlanta and Nashville Expositions and do a great and lasting good in convincing thinking people of the possibilities of the Negro."[4]

Representation at this, and other International Expositions, was an important issue for African-Americans. Blacks had been denied official participation in the 1893 World's Columbian Exposition, a situation strongly protested against by figures such as Ida B. Wells and Frederick Douglass.[5] Considerable attention had been granted to them as a result of Black participation at the 1895 Atlanta and 1897 Nashville Expositions.

Calloway, through the intervention of Booker T. Washington, eventually received support for the project from President McKinley. On November 15, 1899, just four months before the Exposition was to open, he was appointed special agent for the Exhibit (Department of Education and Social Economy). At

the same time, fifteen thousand dollars was appropriated by Congress to fund the project.[6]

Calloway enlisted his former classmate from Fisk University, the sociologist W. E. B. Du Bois, to help him create the exhibit. Additional help came from Daniel A. P. Murray, assistant to the Librarian of Congress. Murray's main contribution was a bibliography of 1,400 works by Negro authors, the collection of 200 titles by Black writers that were sent to the Exposition, together with 150 periodicals. Du Bois was given $2,500 to create an exhibit on Negro life in Georgia. In addition, over a dozen historic black colleges contributed materials to the Exhibit.

Daniel A. P. Murray

Implicit in the organization and content of the Exhibit of American Negroes was a single overarching question: "What was the condition of the African-American people as they entered the twentieth century?" More specifically, Calloway was interested in showing "ten things concerning the negroes in America since their emancipation: (1) Something of the negro's history; (2) education of the race; (3) effects of education upon illiteracy; (4) effects of education upon occupation; (5) effects of education upon property; (6) the negro's mental development as shown by the books, high class pamphlets, newspapers, and other periodicals written or edited by members of the race; (7) his mechanical genius as shown by patents granted to American negroes; (8) business and industrial development in general; (9) what the negro is doing for himself through his own separate church organizations, particularly in the work of education; (10) a general sociological study of the racial conditions in the United States."[7]

These ten topics and the larger question of what life was like for African-Americans at the beginning of the twentieth century is the main interest of this book. By reconstructing the Exhibit of American Negroes, and drawing upon much of the information and sources used to construct the original exhibit, a snapshot is provided of the lives and experience of the first generation of African-Americans to live following Emancipation in the United States. In this context, this work is an attempt at historical archeology. Almost completely ignored in scholarly circles, the Exhibit of American Negroes represents the great lost archive of African-American culture from the beginning of the twentieth century.[8]

The chapters of this book, and their organization, largely follow the logic and content of the exhibit. Following this preface, the book proceeds to an Introduction.

Chapter One, then sets the exhibit, its content, and particularly, W. E. B. Du Bois's role in shaping it, in context. Chapter Two includes a list of awards received by the exhibit. This is followed by Chapter Three, a list of events for the year 1900. Chapter Four is an "index" of cultural and sociological facts and statistics describing the condition of African-American life in 1900. The book then proceeds to Chapter Five, "Black Businesses, Organizations and Occupations." Chapter Six, explores "Black Churches and Religion." Chapter Seven, is an examination of "Black Homes and Families." Chapter Eight, describes "Black Colleges and Universities." Chapter Nine, reconstructs materials from "The Georgia Negro Exhibit (Part I, Charts)." Chapter Ten, looks at "The Georgia Negro Exhibit (Part II, Photographs)." Chapter Eleven, includes "Books and Pamphlets by Negro Authors." Chapter Twelve, includes a list of "Black Codes" sent to Paris. Chapter Thirteen provides a brief Afterword and concludes the book.

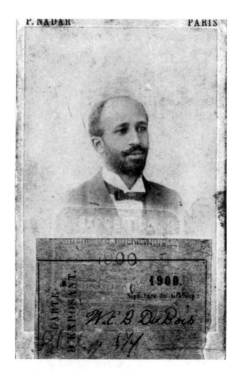

W. E. B. Du Bois's exhibitor's card for the Paris 1900 Exposition.
Courtesy of the Special Collections and Archives, W. E. B. Du Bois Library,
University of Massachusetts at Amherst.

I would like to thank the many people who have helped me in the completion of this project. The staff of the Prints and Photographic Division at the Library of Congress, particularly Mary Ison, provided invaluable assistance with this project in its early phases nearly twenty years ago. Erik Hansen and Mitch Allen at Altamira Press provided useful suggestions and encouragement through all aspects of the material's development as a book. Sarah Stanton, Kathryn Knigge and Stephanie Brooks at Rowman & Littlefield helped the book realize its final form. My wife Asterie Baker Provenzo, as always, was a thoughtful critic and editor. Alexandra Colbert helped with photographic processing and the development of an exhibit based on Du Bois's Georgia Negro Exhibit (part of the larger Exhibit of American Negroes) put together by the African-American Panoramic Experience Museum (APEX) in Atlanta, Georgia, in early 2005. Thanks go to her and the staff of the APEX Museum, particularly Dan Moore, Sr. and Michele Mitchell. Lewis Wilkinson provided technical assistance and friendship throughout the final development of this book. Theresa Bramblett, designer extraordinaire, provided invaluable production help and support. The staff, particularly its head Rob S. Cox, of the Special Collections and University Archives, University of Massachusetts at Amherst, were particularly helpful. Their preservation of Du Bois material and the creation of online materials is particularly noteworthy. Finally thanks to the provost's office at the University of Miami for providing research funding that supported work in various archives in New York, Washington, D.C. and Amherst, Massachusetts.

Eugene F. Provenzo, Jr.
University of Miami
January 2011

W. E. B. Du Bois's exhibitor's card (reverse side) for the Paris 1900 Exposition.
Courtesy of the Special Collections and Archives, W. E. B. Du Bois Library,
University of Massachusetts at Amherst.

NOTES

1. It should be noted that throughout this work I use terms Black and African-American interchangeably. I avoid the use, as was common in 1900, of the term Negro. I do so with the intention of avoiding the pejorative content frequently associated with the use of the term, while recognizing its significance and the fact that it was used differently by African-Americans and Blacks at the beginning of the twentieth century. When I do use the term negro, it is in the context that Blacks from the period would have used the term.

2. *The Paris Exposition Universelle de 1900* was part of a tradition of European international expositions dating back to the middle of the nineteenth century. In 1851 Prince Albert, Queen Victoria's consort, convinced business and cultural leaders in England that a commercial and business exposition being held in Hyde Park should be open to foreign participants. The Great London Exhibition of 1851, or as it is more commonly known, the "Crystal Palace Exposition," was seen as a means of encouraging international peace, as well as improvements in industrial design and commerce. International expositions soon became a regular event. Major expositions were subsequently held in Paris (1855), Vienna (1873), Philadelphia (1876), Paris (1889) and Chicago (1893).

3. A detailed description of the Exhibit is included in W. H. Tolman, "Social Economics in the Paris Exposition," *The Outlook 6* (October 1900), pp. 312-15. A brief overview of the Exhibit is included in the Library of Congress's *A Small Nation of People: W. E. B. Du Bois and African-American Portraits of Progress* (New York: Amistad, 2003). Also see: Eugene F. Provenzo, Jr., "The Exhibit of American Negroes: Paris 1900 International Exhibit," included in The African-American Multimedia Collection (CD-ROM Archive and Online Data Source, Facts on File, Inc., New York, 1999 and the website The Exhibit of American Negroes: Paris 1900 available at http://129.171.53.1/ep/Paris/home.htm.

4. Thomas J. Calloway, "The American Negro Exhibit at the Paris Exposition," The Colored American, quoted in *A Small Nation of People*, p. 18.

5. See: Ida B. Wells, *The Reason Why the Colored American Is Not in the World's Columbian Exposition*. 1893 in *Selected Works of Ida B. Wells-Barnett* intro. by Trudier Harris (New York: Oxford University Press, 1991), pp. 47-137. Also see: Robert W. Rydell, editor, "The Reason Why the Colored American Is Not in the World's Columbian Exposition" [*The Afro-American's Contribution to Columbian Literature: Ida B. Wells, Frederick Douglass, Irvine Garland Penn, and Ferdinand L. Barnett]* (Urbana and Chicago: University of Illinois Press, 1999), which includes various responses, in addition to Wells's, to the exclusion of Blacks from official participation in the 1893 Exposition.

6. *A Small Nation of People*, p. 18.

7. Thomas J. Calloway, "The Negro Exhibit," p. 463, in *Report of the Commissioner-General for the United States to the International Universal Exposition*, Paris, 1900, Vol. II (Washington, D.C.: Government Printing Office, 1901).

8. An important exception is Miles Everett Travis's recent master thesis Mixed Message: Thomas Calloway and the "American Negro Exhibit" of 1900 (Bozeman, M.T.: Montana State University, 2004). Travis provides an excellent background on the exhibit and the role that Thomas Calloway played in its development.

The Exhibit of American Negroes, Exposition Universelle, Paris 1900.
Reprinted from *The American Monthly Review of Reviews,* Vol. XXII, No. 130,
November 1900, p. 576.

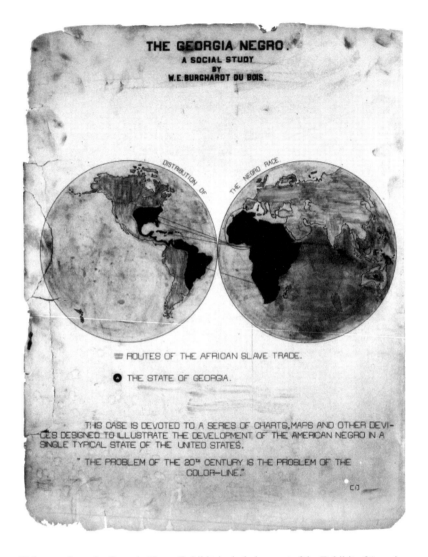

Title page from the Georgia Negro Exhibit, included as part of the Exhibit of American Negroes, Exposition Universelle, Paris 1900.

Introduction: The Exhibit of American Negroes

The quote included on the bottom of the chart on the facing page: "THE PROBLEM OF THE 20TH CENTURY IS THE PROBLEM OF THE COLOR-LINE." is among the most prophetic in American history. It was written by W. E. B. Du Bois for the Exhibition of American Negroes displayed at the 1900 Paris Exposition. They are words whose force echoed throughout the twentieth century, and perhaps more than any other phrase or quote define the meaning of the field of African-American studies.[1]

This book is an attempt at historical reconstruction. It tries as much as possible, within the limitations of the documents that have survived, to recreate and interpret the Exhibit of American Negroes at the 1900 Paris Exposition—an exhibit that was on display for a few brief months, at the dawn of the twentieth century. Like the exhibit, the material in this book tries to summarize the conditions of African-American life and culture at the beginning of the twentieth century.

The work undertaken here is, by definition, imperfect and selective. Although the great majority of the material from the exhibit survives, important parts were lost—in particular the physical artifacts. Nearly all of the materials included in this book are drawn from the Prints and Photography Division of the Library of Congress.

The Exhibit of American Negroes was a collaborative creation of Black colleges and universities and the Library of Congress. The driving intellectual force behind the exhibit was the the Black intellectual and social activist W. E. B. Du Bois.[2] He described the materials sent to Paris as "…an honest straightforward exhibit of a small nation of people, picturing their life and development without apology or gloss, and above all made by themselves. In a way this marks an era in the history of the Negroes of America."[3]

The Exhibit of American Negroes, included as part of Group XVI (Economie Sociale Congres) of the Exposition, was displayed in a large, plain white building built in the style of Louis XVI and located along the banks of the Seine, opposite the *Rue des Nations* and next to the Horticulture building. According to Du Bois, the building and its exhibits were intended to:

> …have housed the world's ideas of sociology. As a matter of fact, any one (sic) who takes his sociology from theoretical treatises would be rather disappointed at the exhibit: for there is little here of the 'science of society.'[4]

The Forestry Building and the globe and the Eiffel Tower from Point Passay.

Instead, according to Du Bois, most of the exhibits in the sociology group at the Exposition were a miscellany and hodgepodge of different aspects of philanthropy and social improvement. Exhibits were included on the building and mutual aid societies of France; the workingman's circles from Belgium; the city governments of Sweden; the Red Cross; and Germany's state insurance program.[5] In the United States section of the building there were models of tenement houses, an exhibit of the American Library Association, and exhibits on industrial regulation.[6]

In the right hand corner of the American exhibit, just as one entered, was the Exhibit of American Negroes, which perhaps more than any other display in Group XVI reflected an attempt to develop an exhibit of scientific sociology. The intention of the exhibit, as described by Du Bois, was:

United States National Building where the Exhibit of American Negroes was displayed.

...to give, in as systematic and compact a form as possible, the history and present condition of a large group of human beings.[7]

The exhibit was "planned and executed by Negroes, and collected and installed under the direction of a Negro special agent, Mr. Thomas J. Calloway."[8] The purpose of the exhibit was fourfold: first, to show the history of the American Negro; second, to describe "his present condition," third his "education;" and fourth "his literature."[9]

Calloway was a lawyer and Booker T. Washington's vice president at Tuskegee Institute in Alabama. The historian Robert Rydell points out that although they were collaborators on the exhibit, W. E. B. Du Bois and Daniel A. P. Murray, who was responsible for the collection of books and pamphlets by Black authors sent by the Library of Congress as part of the Exhibit, disagreed with Calloway about how the exhibit should function.[10] Their differences anticipated the significant divisions that would emerge between Du Bois and Washington within the next few years.

Looking through the Eiffel Tower to the Trocadero and Colonial Section.

Calloway, representing the "Hampton" or "Tuskegee Model," saw Blacks as assuming an accommodationist position where they would not significantly compete with whites for positions of leadership and power in American culture. Implicit in this approach was an acceptance of the idea that Blacks were different and inferior to the mainstream white population—an idea popularized by Washington in 1895 as part of his famous "Atlanta Compromise Speech." As Washington argued:

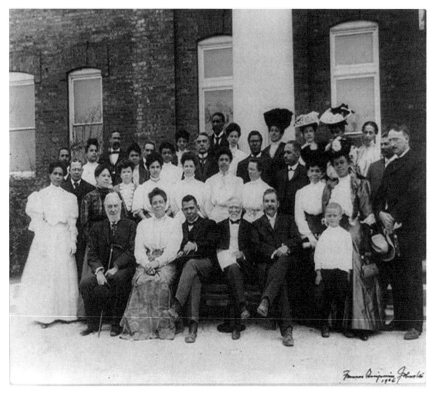

Tuskegee Institute faculty with Booker T. Washington and Andrew Carnegie, Tuskegee, Alabama, 1907. Shown from left to right, seated in front row: R. C. Ogden; Mrs. Booker T. Washington; Booker T. Washington; Andrew Carnegie; and an unidentified person.

> Our greatest danger is that in the great leap from slavery to freedom we may overlook the fact that the masses of us are to live by the productions of our hands, and fail to keep in mind that we shall prosper in proportion as we learn to dignify and glorify common labour and put brains and skill into the common occupations of life; shall prosper in proportion as we learn to draw the line between the superficial and the substantial, the ornamental gewgaws of life and the useful. No race can prosper till it learns that there is as much dignity in tilling a field as in writing a poem. It is at the bottom of life we must begin, and not at the top. Nor should we permit our grievances to overshadow our opportunities.[11]

Du Bois publicly rejected Washington's compromise position in 1903 when he wrote in *The Souls of Black Folk* that as a result of the compromise, Washington was sacrificing for African-Americans:

> First, political power, Second, insistence on civil rights,Third, higher education of Negro youth…[12]

In responding to Washington, Du Bois argued that absolute equality was a right, and that Blacks were as capable of assuming roles of leadership and distinction in the culture as the mainstream white population.

These assumptions are clear in the materials Du Bois and Murray developed for the Exhibit of American Negroes. As evidenced in the photographs, exhibit charts, and book displays sent to the Paris Exposition, and reproduced in large part in this book, a very clear narrative was developed by Murray and Du Bois about the accomplishments of Black Americans since Emancipation, their training and entry into the professions, and their development of a rich and vibrant literary culture.

Crowds in front of the United States National Building on its opening.

This approach was in marked contrast to that taken by Washington and his followers. Compare the vision of Du Bois and his description of the Exhibit of American Negroes as "an honest straightforward exhibit of a small nation of people, picturing their life and development without apology or gloss" to Washington's comments in 1895 about the Black exhibit at the Atlanta Exposition included in his "Compromise" speech:

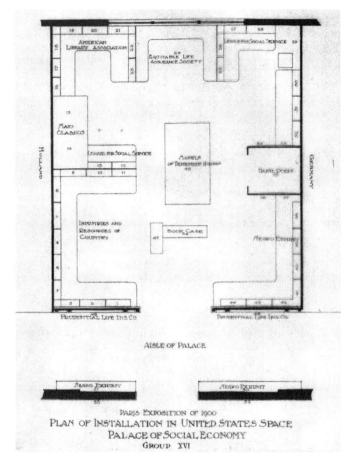

American exhibit hall space at the Palace of Social Economy. The "Negro Exhibit" is included at the bottom left of the entrance. Source: *Report of the Commisioner General of the United States to the International Universal Exposition*, Paris 1900, Vol. 2.

Gentlemen of the Exposition, as we present to you our humble effort at an exhibition of our progress, you must not expect overmuch. Starting thirty years ago with ownership here and there in a few quilts and pumpkins and chickens (gathered from miscellaneous sources), remember the path that has led from these to the inventions and production of agricultural implements, buggies, steam-engines, newspapers, books, statuary, carving, paintings, the management of drugstores and banks, has not been trodden without contact with thorns and thistles. While we take pride in what we exhibit as a result of our independent efforts, we do not for a moment forget that our part in this exhibition would fall far short of your expectations but for the constant help that has come to our educational life, not only from the southern States, but especially from northern philanthropists, who have made their gifts a constant stream of blessing and encouragement.[13]

For Du Bois there was no "compromise"—no assumption that American Blacks needed to assume a role of submission. Equality was the only option. As Robert Rydell has explained:

> As Du Bois described it, the Negro exhibit was anything but a model colonial show. There were, to be sure, photographs and artifacts from the industrial schools, but these were supplemented with exhibits from Howard and Atlanta universities showing the accomplishment of professional schools, "especially in medicine, theology and law." And Du Bois's own statistical survey of Black life in Georgia did not present a "rose-colored picture." His statistics, in fact, confounded stereotypes by depicting a Black population divided between different occupations, some of whom controlled and paid taxes on nearly one million acres of land.[14]

Du Bois confronted stereotypes in many ways in the exhibit. Besides compiling significant statistical data that could be used for analysis and comparison, Du Bois showed clear evidence of the challenges faced by African-Americans. His inclusion of a compilation of Black Laws or "Codes" in Georgia dating from 1865 to 1900, consisting of over three-hundred pages of tediously hand-copied legal documents (a task undertaken by Du Bois and his students), provided irrefutable evidence of how Blacks had been systematically discriminated against as part of the legal system in Georgia.[15]

In addition, Du Bois exploded mainstream ideas about the lack of Black accomplishments by including exhibit materials about African-American patent holders and inventors, highly ranked government clerks and Congressional Medal of Honor winners. Added to this was the compilation of a bibliography of approximately 1,400 books and pamphlets by Black authors that were sent to the Exposition by Murray and the Library of Congress.

What was the context that W. E. B. Du Bois came from and how did it influence his work on the Exhibit of American Negroes? Du Bois had received undergraduate training at Fisk and Harvard University and graduate training at Harvard and the University of Berlin in history, economics, and sociology. Early in his career he focused on empirical sociology, committing himself to the study of Black history, sociology, and culture in the United States.[16] After teaching classics at Wilberforce University in Ohio for two years, he was hired in 1896 by the University of Pennsylvania to conduct a sociological study of Blacks in Philadelphia. The results of his research were published in 1899 under the title *The Philadelphia Negro*, a work many consider the beginning of Urban Sociology in the United States.[17] In 1897, he accepted a teaching and research position at Atlanta University, where he took over the responsibility for the Atlanta Conferences—what many would today argue represents the origins of the field of Black Studies in the United States.

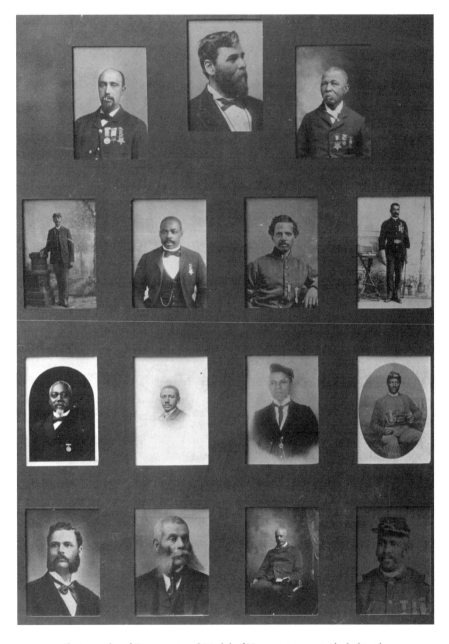

Photographs of Congressional Medal of Honor winners included in the
Exhibit of American Negroes.

The Atlanta Conferences were devoted to conducting systematic sociological studies of the conditions of African-Americans in the United States. The results from these studies were published by Atlanta University in sixteen annual reports (1898-1914). As Du Bois explained in 1904 about the Conferences and their purpose:

> The object of the Atlanta Conference is to study the American Negro. The method employed is to divide the various aspects of his social condition into ten great subjects. To treat one of these subjects each year as carefully and exhaustively as means will allow until the cycle is completed. To begin then again on the same cycle for a second ten years. So that in the course of a century, if the work is well done we shall have a continuous record on the condition and development of a group of 10 to 20 millions of men—a body of sociological materials unsurpassed in human annals.[18]

Du Bois was acutely aware that the sociological studies he was undertaking were limited by the newness of sociology as an academic field—one in which the work was "always wearisome, often aimless, without well-settled principles and guiding lines."[19] At the same time he was sensitive to the need to develop new methods and techniques that would expand sociology as a science. As he explained:

> The present condition of sociological study is peculiar and in many respects critical. Amid a multitude of interesting facts and conditions we are groping after a science—after reliable methods of observation and measurement, and after some enlightening way of systematizing and arranging the mass of accumulated material.[20]

Du Bois clearly felt that the social and cultural conditions in the United States provided a particularly exciting and challenging environment "for observing the growth and evolution of society."[21] If a true science of sociology was to be developed, Du Bois argued that it would be necessary for researchers to limit themselves:

> ...to the minute study of limited fields of human action, where observation and accurate measurement are possible and where real illuminating knowledge can be had.[22]

For Du Bois, the "careful exhaustive study of the isolated group" was ideal.[23] From a thorough study of groups like the American Negro it would be possible to develop "cautious generalization and formulation."[24] In his mind, there was no better or more interesting group to study than African-Americans:

THE TENTH ANNUAL

ATLANTA CONFERENCE

TO STUDY

THE NEGRO PROBLEMS

ASSEMBLES AT

ATLANTA UNIVERSITY, ATLANTA, GA.

ON

TUESDAY, MAY 30, 1905

GENERAL SUBJECT

"Methods and Results of Ten Years' Study of the
American Negro"

THE ATLANTA UNIVERSITY STUDIES

THE FIRST CYCLE, 1896-1905 A Vista of Results	THE SECOND CYCLE, 1906-1915 A Vision of Work
1896—Mortality	1906—Physique
1897—The Family	1907—The Family
1898—Social Betterment	1908—Organization
1899—Business	1909—Economic Development
1900—College-bred Negroes	1910—Economic Development
1901—Common Schools	1911—Education
1902—The Artisan	1912—Political Power
1903—The Church	1913—The Church
1904—Crime	1914—Crime
1905—Methods and Results	1915—Methods and Results

African Conditions
Historical Research

Announcement for the 1905 Meeting of the Atlanta Conference. Courtesy of the
University of Massachusetts at Amherst.

I think it may safely be asserted that never in the history of the modern world has
there been presented to men of a great nation so rare an opportunity to observe
and measure and study the evolution of a great branch of the human race as is
given to Americans in the study of the American Negro. Here is a crucial test
on a scale that is astounding and under circumstances peculiarly ...fortunate.[25]

Black Americans had been isolated as a social group as a result of "color
and color prejudice." They represented a group, who because of "the peculiar
environment, the action and reaction of social forces are seen and can be
measured with more than usual ease." By studying the experience of Blacks, Du
Bois believed that he could address questions such as: "What is human progress
and how is it emphasized?" "How do nations rise and fall?" "What is the meaning
and value of certain human actions?"[26]

Du Bois felt that:

> ...here in America we have not only the opportunity to observe and measure nearly all the world's great races in juxtaposition, but more than that to watch a long and intricate process of amalgamation carried on hundreds of years and resulting in millions of men of mixed blood.[27]

As a sociologist, Du Bois was motivated to understand the consequences of "eight million persons of African descent" living in the United States. He felt that the African-American experience had been neglected because of the sensitivity— both Black and White—over color-mixing.[28]

In 1897, the same year that he became a professor at Atlanta University, Du Bois delivered an address entitled "The Conservation of Races" before the American Negro Academy, an early Black scholarly organization. In this address, Du Bois argued for American Blacks to act as the "advance guard" in Black racial development throughout the world. According to him:

> ...the advance guard of the Negro people—the 8,000,000 people of Negro blood in the United States of America—must soon come to realize that if they are to take their just place in the van of Pan-Negroism, then their destiny is not absorption by the white Americans. That if in America it is to be proven for the first time in the modern world that not only Negroes are capable of evolving individual men like Toussaint, the Saviour, but are a nation stored with wonderful possibilities of culture, then their destiny is not a servile imitation of Anglo-Saxon culture, but a stalwart originality which shall unswervingly follow Negro ideals.[29]

Du Bois maintained that American Blacks were Americans not only by birth and citizenship, but also in terms of religion, political values, and language. Yet, he also considered Blacks to be separate from their American experience:

> ...Members of a vast historic race that from the very dawn of creation has slept, but half awakening in the dark forests of its African fatherland. We are the first fruits of this new nation, the harbinger of that black tomorrow which is yet destined to soften the whiteness of the Teutonic today.[30]

Du Bois argued that in order for American Blacks to become a vanguard of this "new nation," they would need to establish race organizations, black colleges, black newspapers, black business organizations, black schools of literature and art and an intellectual clearing house for all of these activities—a Black, or "Negro Academy."[31]

The Exhibit of American Negroes at the Paris 1900 Exposition provided Du Bois with an important opportunity to not only advance the sociological study of Blacks, but also to begin to bring into focus the intellectual and social accomplishments of Black Americans.

The exhibit in Paris was important for a number of reasons. For contemporary historians and sociologists, it provides an extraordinary snapshot of the conditions of Black culture and society in the United States at the turn of the century. At the same time, it represents an important stage in Du Bois's work as an empirical sociologist and as a critical commentator on race in the United States. In the exhibit—particularly in the example of Du Bois's study of the Georgia Negro— are found the fundamental components a new sociology of Black Americans, as well as a review of the social, cultural, literary, and political experience of Black Americans from the Colonial period to the year 1900.

How important the exhibit was at the time was difficult to determine. In his *Autobiography*, Du Bois reflected on the exhibit—his main contribution to the exhibit which dealt with the Georgia Negro:

> In 1900 came a significant occurrence which not until lately have I set in its proper place in my life. I had been for over nine years studying the American Negro problem. The result had been significant because of its unusual nature and not for its positive accomplishment. I wanted to set down its aim and method in some outstanding way which would bring my work to the notice of the thinking world. The great World's Fair at Paris was being planned and I thought I might put my findings into plans, charts, and figures, so one might see what we were trying to accomplish. I got a couple of my best students and put a series of facts into charts: the size and growth of the Negro American group; its division by age and sex; its distribution, education, and occupations; its books and periodicals. We made a most interesting set of drawings, limned on pasteboard cards about a yard square and mounted on a number of moveable standards.[32]

Approximately sixty charts were included, carefully illustrated with hand-colored graphs and black-and-white photographs. They were mounted on hinges so that they could swing out from the wall of the exhibit. Du Bois recalled having relatively little time to do the project, almost no money to finance it, and little encouragement:

> I was threatened with nervous prostration before I was done and had little money left to buy passage to Paris, nor was there a cabin left for sale. But the exhibit would fail unless I was there. So at the very last moment I bought passage in steerage and went over and installed the work.[33]

The exhibit which Du Bois described as occupying a room "perhaps 20 feet square," was an immediate success.[34] Black and White newspapers in the United States reported positively on its organization and contents. The general exhibit was awarded a Grand Prize by the organizers of the Exposition, and Du Bois a gold medal for his efforts.[35]

From a contemporary historical perspective, the Exhibit of American Negroes is particularly important because it represented a significant counterargument to Booker T. Washington's model of compromise and accommodation introduced in 1895 at the Atlanta Exposition. Du Bois and Murray's contributions to the Exhibit—their selection and display of materials about Black life and culture in the United States—represented a powerful narrative that refuted the assumptions of Washington's compromise.

While it would be another three years before Du Bois published his critique of Washington in *The Souls of Black Folk*, the evidence for his argument was clearly assembled in the exhibits and materials sent to Paris as part of the Exhibit of American Negroes. It is in this context that the materials from the exhibit should be understood. As such, they represent an extraordinary moment in American history, as well as a remarkable set of documents for us to examine and interpret over a century later.

W. E. B. Du Bois in Paris in 1900.
Courtesy of the University of Massachusetts at Amherst.

NOTES

1. This quote was widely disseminated through the publication of Du Bois's *The Souls of Black Folk* (1903), where it begins chapter II, "The Dawn of Freedom." It was also included in an *Atlantic Monthly* article published prior to *The Souls of Black Folk*. The inclusion of the quote as part of the Exhibit of American Negroes is almost certainly the quote's first public use. For background on the *1900 Paris Exposition Universelle* see Robert W. Brown, "Paris 1900," in the *Historical Dictionary of World's Fairs and Expositions, 1851-1988*, John E. Findling and Kimberly D. Pelle, eds. (New York: Greenwood Press, 1990), and Richard D. Mandell, *Paris 1900: The Great World's Fair* (Toronto: University of Toronto Press, 1967).

2. For background on Du Bois, the best starting point is his first autobiography, *Dusk of Dawn: An Essay Toward and Autobiography of a Race Concept*, introduction by Irene Diggs (New Brunswick, N.J.: Transaction Books, 1984), which was published in 1940. A second autobiography which included much of the same material as *Dusk of Dawn* is *The Autobiography of W. E. B. Du Bois: A Soliloquy on Viewing My Life from the Last Decade of Its First Century* (New York: International Publishers, 1968). This second autobiography appeared five years after Du Bois died. Thus, he did not have editorial control over the final content of the work The major scholarly and biographical studies of Du Bois include: Francis Broderick, *W. E. B. Du Bois, Negro Leader in a Time of Crisis* (Palo Alto, CA: Stanford University Press, 1959); Elliott Rudwick, *W. E. B. Du Bois: A Study in Minority Group Leadership* (Philadelphia: University of Pennsylvania Press, 1960); Elliott Rudwick, *W. E. B. Du Bois* (New York: Atheneum, 1968); Virginia Hamilton, *W. E. B. Du Bois* (New York: T. Y. Crowell, 1972); Virginia Hamilton, *Black Titan: W. E. B. Du Bois* (Boston: Beacon Press, 1970); Manning, Marable. *W. E. B. Du Bois: Black Radical Democrat* Boston: Twayne, 1986; David Levering Lewis, *W. E. B. Du Bois: Biography of a Race* (New York: Henry Holt and Company, 1993); and David Levering Lewis, *W. E. B. Du Bois The Fight for Equality and the American Century 1919-1963* (New York: Henry Holt & Company, 2000).

Du Bois's correspondence has been published as a three volume collection under the title *The Correspondence of W. E. B. Du Bois* (Amherst: University of Massachusetts Press, 1973-1978). Invaluable for any work on Du Bois is Herbert Aptheker's *Annotated Bibliography of the Published Writings of W. E. B. Du Bois* (Millwood, N.Y.: Kraus-Thomason Organization, 1973).

3. William Edgar Burghardt Du Bois, "The American Negro at Paris," *The American Monthly Review of Reviews*, vol. XXII (November 1900), p. 577. no. 5.

4. Ibid., p. 575.

5. Ibid.

6. Ibid. Robert Rydell provides an outstanding introduction to American involvement at the Paris 1900 Universal Exposition in his essay "Gateway to the 'American Century': The American Representation at the Paris Universal Exposition of 1900," pp. 118-144, in Diane P. Fischer, editor, *Paris 1900: The American School at the Universal Exposition* (New Brunswick, N.J.: Rutgers University Press, 1999).

7. Du Bois, "The American Negro at Paris," p. 576.

8. Ibid.

9. Ibid.

10. Rydell, in Fischer, p. 141. While Calloway was a friend of Du Bois's from Fisk, he was also a protégé of Washington's and tended to revert back to Washington's more conservative position, rather than the more radical models of Du Bois. See Miles Everett Travis, *Mixed Message: Thomas Calloway and the "American Negro Exhibit" of 1900* (Bozeman, M.T.: Montana State University, April 2004), p. 4.

11. Booker T. Washington's "Atlanta Compromise" Speech (September 18, 1895), included in the Facts On File, Inc. CD-ROM, African-American History and Culture. New York, NY: Facts On File, Inc., 1999).

12. W. E. B. Du Bois, *The Souls of Black Folk* included in *W. E. B. Du Bois: Writings* (New York: The Library of America, 1986), p. 398.

13. Washington, op. cit.

14. Rydell, op. cit., pp. 141-142.

15. Du Bois had included a similar compilation of laws affecting the slave trade in his classic 1896 work, *The Suppression of the African Slave Trade in the United States of America, 1638-1870*; Harvard Historical Studies Number 1 (1896).

16. For background on Du Bois as a sociologist see: *W. E. B. Du Bois: On Sociology and the Black Community*, edited and with an introduction by Dan S. Green and Edwin D. Driver (Chicago: The University of Chicago Press, 1978).

17. W. E. B. Du Bois, *The Philadelphia Negro: A Social Study* (1899; New York: Benjamin Blom, 1967).

18. "The Atlanta Conferences," *Voice of the Negro* (March, 1904): pp. 85-89. Reprinted in *W. E. B. Du Bois: On Sociology and the Black Community*, p. 58. The subjects of the conferences included studies on Black business, Black artisans, Black economic cooperation and social self-improvement organizations, college-educated Blacks, public education for Blacks, issues related to health, crime and morality in the Black community, Black family life and the role of Black churches. The annual reports from the conference were republished in a multivolume series in 1969 by Russell & Russell, New York, under the title *The Atlantic University Publications*.

19. "The Study of Negro Problems," *The Annals of the American Academy of Political and Social Science*, vol. 11 (January 1898), reprinted in *W. E. B. Du Bois on Sociology and the Black Community*, p. 70.

20. "The Atlanta Conferences," *Voice of the Negro* (March, 1904): pp. 85-89. Reprinted in *W. E. B. Du Bois: On Sociology and the Black Community*, p. 53.

21. Du Bois, "The Study of Negro Problems," p. 70.

22. "The Atlanta Conferences," op. cit., p. 54.

23. Ibid.

24. Ibid.

25. Ibid.

26. Ibid.

27. Ibid., pp. 55-56.

28. Du Bois, "The Study of Negro Problems," p. 71.

29. "The Atlanta Conferences," op. cit., p. 55. According to Du Bois:

...because the subject of amalgamation with black races is a sore point with us, we have hitherto utterly neglected and thrown away every opportunity to study and know this vast mulatto population and have deliberately and doggedly based our statements and conclusions concerning this class upon pure fiction or unvarnished lies. (Ibid., pp. 55-56)

30. W. E. B. Du Bois, "The Conservation of the Races," *American Negro Academy, Occasional Papers*, No. 2, 1897, reprinted in *W. E. B. Du Bois: Writings*, p. 820.

31. Ibid., p. 822.

32. Ibid.

33. William Edgar Burghardt Du Bois, *The Autobiography of W. E. B. Du Bois: A Soliloquy on Viewing My Life from the Lasr Decade of Its First Century* (New York: International Publishers, 1968), pp. 220-221.

34. Ibid., p. 221.

35. Ibid.

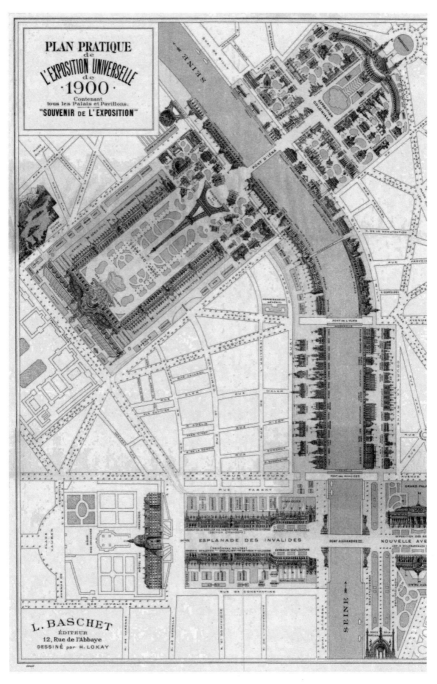

"Plan Pratique" for the *1900 Universal Exposition*, Paris, France.

Silver medal for the *1900 Universal Exposition*, Paris, France.
Diameter: 63mm

Awards Received by the Exhibit of American Negroes at the *1900 Paris Universelle Exposition*

Grand Prix

American Negro Exhibit (on the collection as a whole); Hampton Normal and Agricultural Institute, Hampton, Virginia.

Gold Medals

Tuskegee Normal and Agricultural Institute, Tuskegee, Alabama; Howard University, Washington, D.C; Thomas J. Calloway, Special Agent, as Compiler of the American Negro Exhibit; William Edgar Burghardt Du Bois, Collaborator, as Compiler of the Georgia Negro Exhibit.

Silver Medals

Fisk University, Nashville, Tennessee; Agricultural and Mechanical College, Greensboro, North Carolina; Berea College, Berea, Kentucky; Atlanta University, Atlanta, Georgia; Booker T. Washington, Monograph on Education of Negro.

Bronze Medals

Roger Williams University, Nashville, Tennessee; Central Tennessee College, Nashville, Tennessee; Atlanta University, Atlanta, Georgia; Pine Bluff Normal and Industrial School, Pine Bluff, Arkansas.

Honorable Mention

Haines Normal and Industrial Institute, Augusta, Georgia; Claflin University, Orangeburg, South Carolina.[1]

NOTES

1. William Edgar Burghardt Du Bois, "The American Negro at Paris," The American Monthly Review of Reviews, Vol. XXII, November 1900, #5, p. 575-577. Du Bois commented on the awards given to the exhibit that:

While these awards represent the appreciation of several juries, taken together there is not the even balancing that might be wished. Some of the principal features were not installed until after the juries were disbanded… The awards, therefore, except in certain cases like Hampton, Tuskegee, Atlanta, etc., do not necessarily represent the strongest features of the exhibit. Ibid., p. 57.

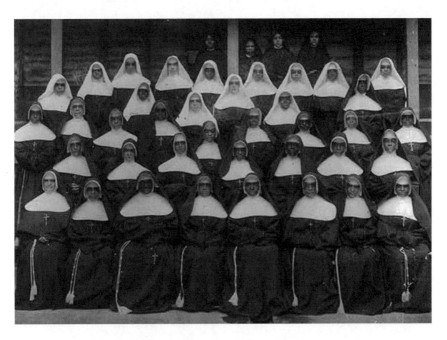

Sisters of the Holy Family, New Orleans, Louisiana.
In album (disbound): Negro Life in Georgia

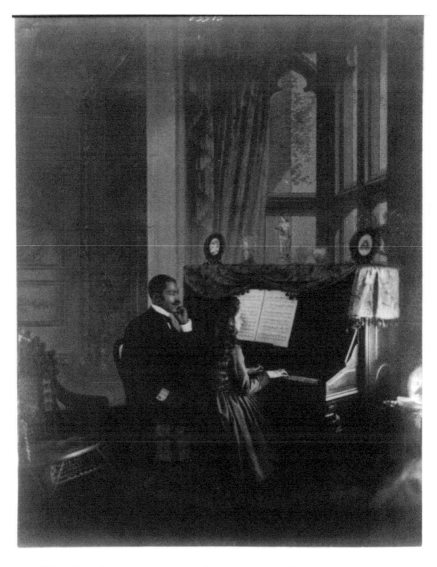

African-American man giving piano lesson to young African-American woman.
In album (disbound): Negro Life in Georgia, U.S.A.,
compiled and prepared by W. E. B. Du Bois, v. 4, no. 363.

Events for the Year 1900

The following events that took place in 1900 provide a context for African-American life and culture during the same period.

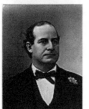

- The Boer War is fought in South Africa. A young military officer, Winston Churchill, is serving on the front.

- Henry Ford introduces the first of his automobiles manufactured in Detroit.

- Actress Sarah Bernhardt performs to sold-out crowds in London.

- Seven thousand Chicago construction workers go on strike demanding an eight-hour work day.

- The novelist Theodore Dreiser publishes *Sister Carrie*.

- Vladimir Illich Lenin emigrates to Switzerland beginning a five-year exile from Russia.

- The Labour Party is founded in Great Britain.

- Hawaii and Puerto Rico become United States territories.

- Paris hosts the Summer Olympics.

- Booker T. Washington's National Negro Business League is founded in Boston. Its purpose is to encourage the development of African-American businesses.

- The International Ladies' Garment Workers Union is founded in New York City.

- Carrie Nation begins her temperance crusade.

- William Jennings Bryan is nominated as the presidential candidate for the Democratic Party.

- Railroad engineer Casey Jones is killed while trying to save passengers on a runaway train in Mississippi.

- Solar eclipse darkens much of North America.

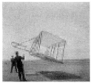

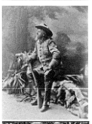

- Orville and Wilbur Wright conduct glider and kite experiments at Kitty Hawk, North Carolina.

- Race riots take place in New Orleans.

- Paris opens its first subway system.

- The German philosopher and poet Friedrich Nietzsche dies.

- German Count Ferdinand Von Zeppelin launches his 416 foot-long aircraft—which becomes known as a zeppelin.

- Army Surgeon Dr. Walter Reed conducts experiments in Cuba and proves that yellow fever is a disease that is transmitted by mosquitoes.

- "Buffalo Bill" Cody performs at New York's Madison Square Garden.

- Racial conflicts erupt in Raleigh, North Carolina over restriction of the voting rights of African-Americans.

- Frank Baum publishes his novel *The Wizard of Oz*.

- Oscar Wilde dies in Paris at age forty-nine.

- The Colored Men's Branch of the YMCA opened in New York City is accepted by the national YMCA as a normal branch of the organization.

- Helen Keller is admitted to Radcliffe.

- The Boxer Rebellion breaks out in China.

- The American Baseball League is formed.

- Andrew Carnegie and William Jennings Bryan emerge as vocal opponents of what they see as growing imperialism resulting from the United States actions in the Philippines.

- Carnegie Steel Corporation is formed.

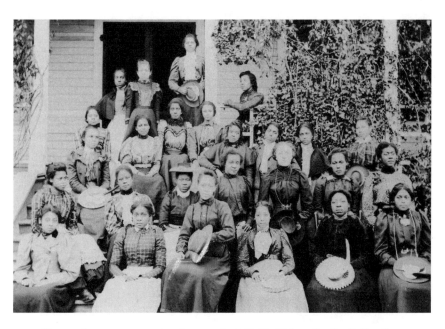

Group of young women posed on porch at Claflin University, South Carolina.

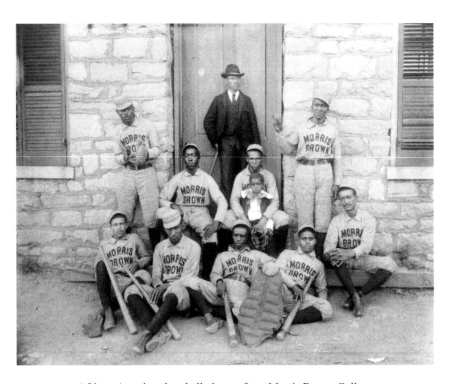

African-American baseball players from Morris Brown College

African-American Census Indicators for 1900

The following facts and statistics are drawn from the 1900 United States Census, Department of Commerce and Labor's Bulletin 8, *Negroes in the United States* (Washington: Government Printing Office, 1904).

- Negro males living in the United States: 4,317,157.

- Negro Females living in the United States: 4,370,003.

- Total Negro population in the United States: 9,204,531.

- Total Population of the United States: 74,607,225.

- Between 11% and 16% of all Negroes have some White ancestry.

- 89.7% of Negroes living in the United States live in the South.

- 31.4% of Negroes live in Georgia, Mississippi and Alabama.

- Center of the Negro population is DeKalb County, Alabama.

- In 1790 the center of the Negro population was near Petersburg, Virginia.

- 77.3% of Negroes live in the country.

- In the South Negroes represent 30.9% of the population in cities.

- In the South Negroes are 32.6% of the population in the country.

- In the North and West Negroes are 2.4% of the city populations.

- In the North and West Negroes are 1.1% of the city population.

- Between 1860 and 1890 the Negro population in the South increased 93.4%.

- Between 1860 and 1890 the White population in the South increased 134.9%.

- Half of all Negroes in 1900 were below 19.4 years of age and half above.

- 44.5% of all Negroes over ten years of age are illiterate.

- Illiteracy for Negroes over ten years of age was 57.1% in 1890.

- Illiteracy among Negroes is four times higher than that of Southern Whites.

- Illiteracy among Negroes is more common in the country.

- Illiteracy among Negroes is seven times higher than among Whites.

- Negro females are more illiterate than Negro males.

- 60.5% of all Negroes are single.

- 32.5% of all Negroes are married.

- 6.8% of all Negroes are widowed or divorced.

- Negro mortality was approximately double that of the White population.

- 45.3 % of the total Negro population are breadwinners.

- 37.3% of the total population are breadwinners.

Leading occupations for Negroes included servants, waiters, draymen, hackmen, teamsters, miners, quarrymen, saw and mill workers, porters, store assistants, teachers, nurses, clergy, midwives, hostlers, stone and brick masons, dressmakers, iron and steel workers, railroad engineers, firemen, laundresses, fishermen, blacksmiths, housekeepers, cigar makers, carpenters, joiners, and oystermen.

Servants and waiters, miners and quarrymen, saw and planning mill workers, teachers, nurses and midwives, clergy, and iron and steel workers are the seven most common Negro occupations.

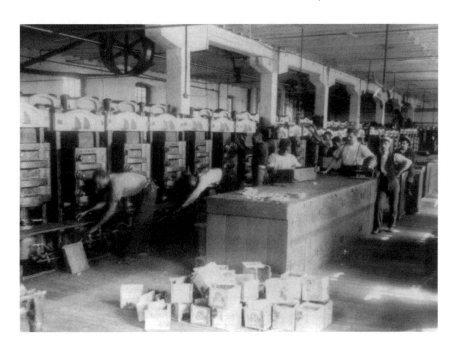

Box making in the T. B. Williams Tobacco Factory, Richmond, Virginia.

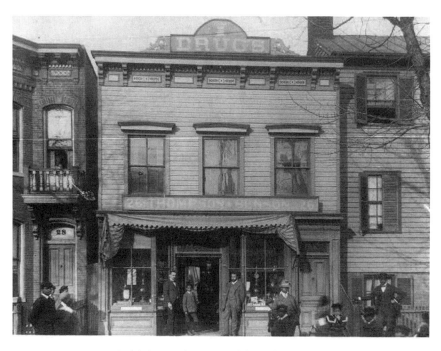

Leigh Street Pharmacy, Richmond, Virginia.

Businesses, Organizations, and Occupations

Photographs of businesses, organizations, occupations, and people were included throughout The Exhibit of American Negroes. Their purpose was to demonstrate the emergence of a skilled black middle class, as well as to show a number of the industries and businesses in which African-Americans were involved across the United States.

In May of 1899, less than a year before the opening of the exhibit in Paris, Du Bois had sponsored the Fourth Atlanta University Conference. Its subject was Black businesses. The conference and its proceedings, *The Negro in Business*,[1] represented the first time Black businesses were systematically studied in the United States. The proceedings for the conference, as all of the Atlanta University Conference Proceedings, were included in the book section of the exhibit at Paris.

As part of the research for the Atlanta University Conference, Du Bois sent "schedules" of questions to approximately fifty co-researchers to administer in

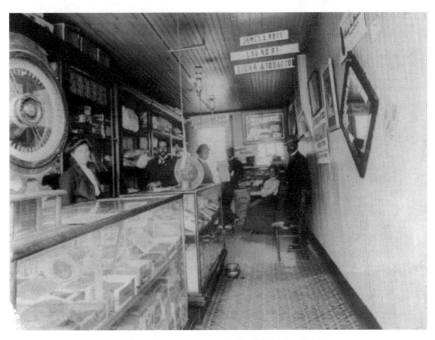

Interior of a Negro store in Buffalo, New York.

local communities throughout the South. While not strictly scientific, Du Bois's research represents the most importance source of data from the end of the nineteenth century in the United States that exists concerning Black businesses and entrepreneurship.

Du Bois saw the establishment of a Black business class as absolutely essential in terms of the advancement of the race. As he explained:

> It is hardly possible to place too great stress on the deep significance of business ventures among American Negroes. Physical emancipation came in 1863, but economic emancipation is still far off. The great majority of Negroes are still serfs bound to the soil or house-servants. The nation which robbed them of the fruits of their labor for two and a half centuries, finally set them adrift penniless.... For a Negro then to go into business means a great deal. It is, indeed, a step in social progress worth measuring. It means hard labor, thrift in saving, a comprehension of social movements and ability to learn a new vocation all this taking place, not by concerted guided action, but spontaneously here and there, in hamlet and city, North and South.[2]

Du Bois made clear that identifying the characteristics of the Black businessman and entrepreneur was "difficult, and yet worth the trial." Du Bois wanted to know different kinds of business ventures that Blacks undertook, "the order of their appearance, their measure of success and the capital invested in them." He wanted to know what sort of people went into business, how long they had pursued their activity, how they got started and where such businesses were being created.

Du Bois, and his co-researchers, compiled numerous statistics about Negro businessmen across the country. As part of their survey for the report, a total of two hundred businessmen sent in detailed accounts of their lives and experiences. Often these accounts were quite detailed. An upholsterer from Baltimore, for example, provided the following account:

> I was born a slave at Petersburg, Va., in the year 1845. My early surroundings were the same that nearly all the race at the South in those days had to face. We were considered chattels and as such had no right to life, liberty and the pursuit of happiness. Unrequited service was my lot. After the outbreak of the civil war the old home lost its attraction for me. During part of '64 and '65 I was employed along with the 13th 0. Cavalry. In '68 I came to Baltimore. For about 18 year I was engaged in the furniture moving business in which I had some success. My next venture was to open an upholstering establishment in the fall of '84. Desiring a permanent location I purchased property at ____st. which, with the improvements since added is now worth five thousand dollars. Besides my shop, I operate a storage ware house in the rear on my premises. I was married in '74. Have one son who is working at the trade with me. I have been a member of Sharo St. M. E. Church for about 26 years. I regret to say that I am not an educated man. All the time spent at school would not exceed a week.... I had

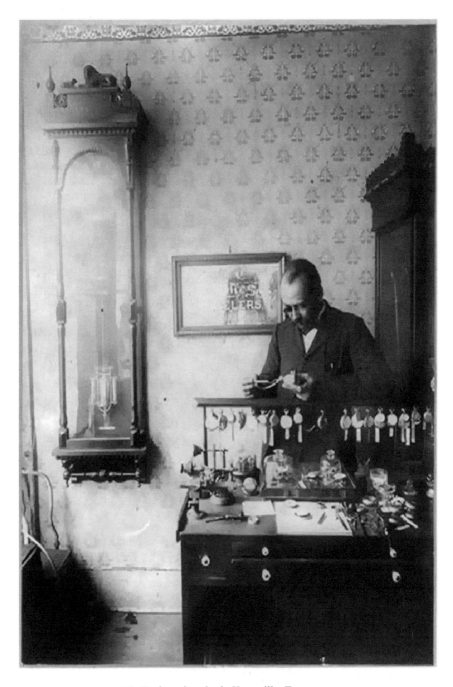

Mr. Dodson, jeweler in Knoxville, Tennessee.

but little capital to begin with. I thought it expedient to proceed cautiously. I had some appreciation of the importance of building up a reputation which requires time as well as work. I made it my aim not simply to get a customer, but to hold him as long as possible. I employed competent workmen and gave strict attention to all the details. I planned to deal on a cash basis. Work was paid for promptly and bills were not allowed to go beyond the time. I have adhered to this course ever since. I determined not only to use my best judgment but also to seek guidance from the Lord. He has aided me.

Considering everything I think I have had fair success. I have been able to save some money and besides, I can boast of having obtained creditable footing among men of business. My shop is never idle. I do not regard quick and large profits as always indicative of success in business. The gain that has not integrity and merit to justify it, may be looked upon with suspicion. I have received considerate treatment at the hands of the white people. The larger part of my patronage comes from that source. They confide in my skill and honesty. They visit my store and I am frequently called to their houses. The contact is friendly, both parties understanding that it is of a business rather than a social character.[3]

A Black jeweler described his experience as follows:

I was born on the island of Barbadoes, British W. I., in the town of Bridgetown. My life has been rather uneventful. My father was a man in fair circumstances and was enabled to give his children some education and provide well for them. Most West Indian parents have their boys to learn some trade after leaving school, even though in some cases they take a profession afterwards, the object being to provide them with a means of earning a living with their hands if they fail to succeed otherwise. So to follow the bent of my mind-mechanics, I was put apprentice to a watchmaker, where I spent five years at the bench, until I had a fair knowledge of the trade. I then came to this country in the spring of '85 where I have remained since.

The popular system of education in the West Indies in my time was private tuition especially for primary instruction. And so I went to several pay schools, and last to a public school, receiving what would be called here a good grammar course. Some reading in later life has been of much benefit to me.

My first venture was in Kansas City. About four months after my arrival in this country, I applied for work at some of the leading jewelry stores of the above city and found out for the first time that the roads to success in this country for the black man were not so free and open as those of his brother in white. So I worked as porter for two years, and then encouraged by the success of pleasing my friends with private work done for them during my leisure hours at my room, I bought a small frame building, opened a watch repairing shop and became Kansas City's first Negro jeweler.

With close attention to business, by observing frugality, and by manifesting a disposition to please my patrons with courteous treatment and efficient work

I have succeeded so my critics say "well." I had the misfortune to lose $500 in a bank failure and the good fortune to have saved enough to be notated in four figures. As regards the second question, it is rather difficult to tell how a white man really regards a Negro, especially when there is something to be gained to the former from the latter. A white man has a remarkable power of self concealment. Those whom I deal with treat me well. Those whom I do not deal with do not molest me. I don't know how they regard me.[4]

Du Bois compiled numerous lists of Black businessmen and professionals in different cities, including not only the number of years they had been working but also the capital they had invested in their businesses. This data, while somewhat fragmentary, provides the reader with a general sense of the types of businesses black entrepreneurs were engaged in, as well as the amounts of money that they invested in their businesses.

In his analysis of Negro merchants in Athens, Georgia, for example, his data describes a series of small businesses, most of which had been running for less than ten years and which produced relatively small incomes. None of the businesses involved much in the way of capital, some as small as $150 for a grocery, $360 for a livery stable, $500 for a barber, and the largest $600 for a grocery store. One of the two grocery stores had a daily average income of $25 and the other $35.

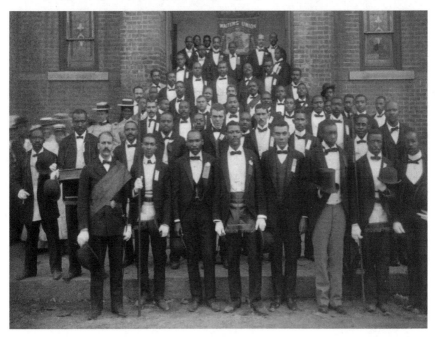

African-American men posed at entrance to building, some with derbies and top hats, and banner labeled "Waiters Union" in Georgia.

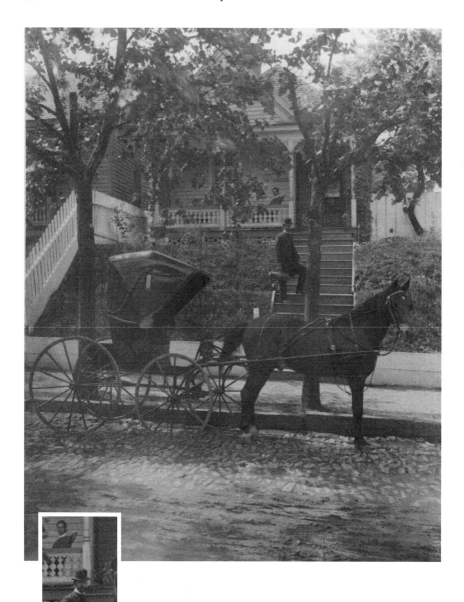

African-American man (doctor?), carrying small leather bag, standing on steps to residence, horse-drawn carriage in the foreground. In album (disbound): Negro Life in Georgia, U.S.A., compiled and prepared by W. E. B. Du Bois, v. 4.

The two barbers averaged incomes respectively of $6 and $10 per day. The livery stable owner had an average daily income of $6 per day.

According to Du Bois:

> The Negro in business has many disadvantages to contend against, especially from the intelligent class of people who regard themselves as the "best class" of Negroes. Experience teaches that the poorer class, or what is commonly called the "common people" are more inclined to support race enterprises, and our professional men than the first class named. The Negro businessman scarcely receives any help outside of his race.[5]

Class and professional lines are clearly at work in African-American culture. Significantly, these are issues that are not taken into account by Du Bois in terms of his theory of "the talented tenth," an elite educated and virtuous segment of the Black population in the United States, whom he hoped would act as a vanguard in leading the African-American population to greater equality and prosperity.

Images of Black businesses and occupations were included throughout the Exhibit of American Negroes, both in the general exhibit, as well as the Georgia Negro Exhibit, which had been assembled largely by Du Bois. Among the most

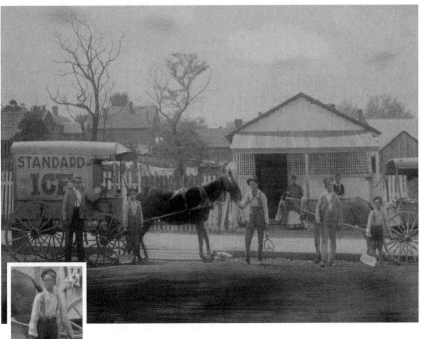

Horse-drawn ice wagon and several persons, two with blocks of ice, standing in street in front of residence.

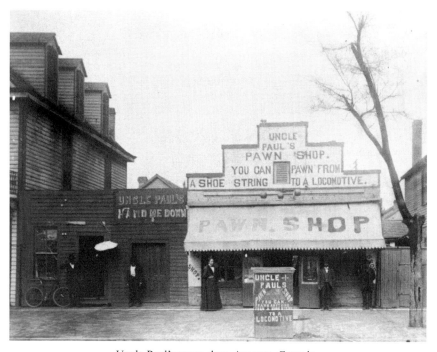

Uncle Paul's pawn shop, Augusta, Georgia.

interesting were the general photographs of Black businesses. These include images of ice delivery companies, pawn broking shops, shoe stores, watchmakers, and pharmacists. A cotton mill operated by Warren C. Coleman in Concord, North Carolina, had not only photographs of the mill and its owner included in the exhibit but also pictures of its Board of Directors.

A particularly rich set of photographs were included from Richmond, Virginia. These included pictures of the Planet Newspaper; a jewelry shop; a shoe shop; a pharmacy; the exterior and interiors of steam laundries; the main office, and the manufacturing floor of the R. J. Williams Tobacco Company.

In terms of the photographs included in the Exhibit of the American Negro numerous images of Black business people and professionals are included. Du Bois, in the Georgia Negro Exhibit,

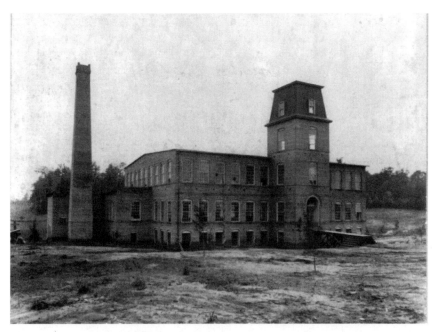

Coleman Manufacturing Company, Concord, North Carolina.

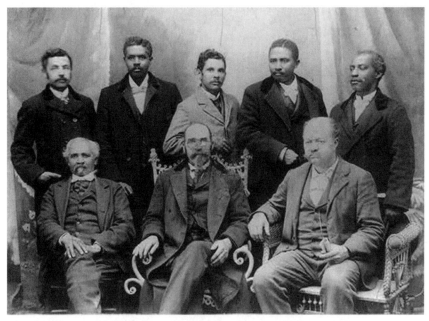

Board of directors of the Coleman Manufacturing Company, Concord, North
Carolina, the only Negro cotton mill in the United States.

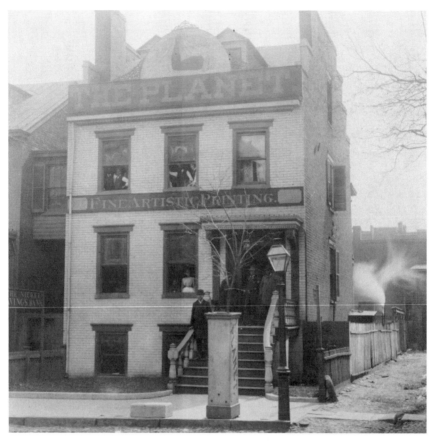

People posed on porch of and in the *Planet* newspaper publishing house, Richmond, Virginia.

particularly includes large numbers of these types of photographs. These images are of interest for many reasons. Most important, from a critical point of view, is the extent to which they contradict Washington and the Hampton model's idea that African-Americans were largely suited to manual work. Instead, it is clear that as a social group, American Blacks are perfectly capable of engaging in businesses and the professions.

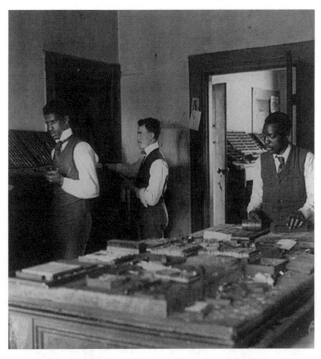

Composing room of the *Planet* newspaper, Richmond, Virginia.

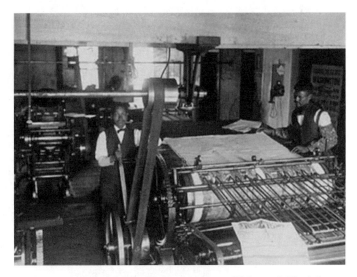

Composing room of the *Planet* newspaper, Richmond, Virginia.

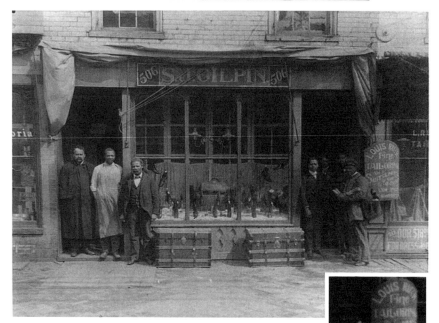

S. J. Gilpin shoe store, Richmond, Virginia.

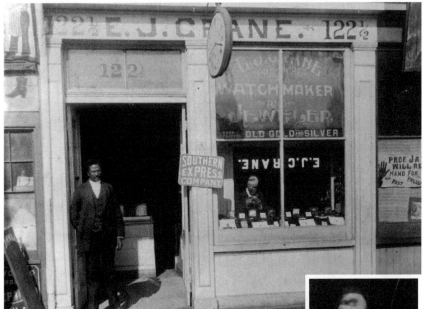

E. J. Crane, watchmaker and jewelry store with man working in window and man standing in doorway, Richmond, Virginia.

NOTES

1. See W. E. B. Du Bois, editor, *The Negro in Business: Report of A Social Study Under the Direction of Atlanta University; Together with the Proceedings of the Fourth Conference for the Study of Negro Problems, Held at Atlanta University, May 30-31, 1899* (Atlanta: GA; Atlanta University, 1899).

2. Ibid, p. 5.

3. Ibid.

4. Ibid.

5. Ibid, p. 39.

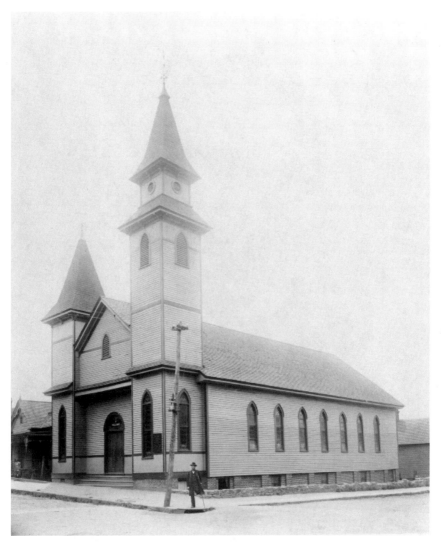

African-American man standing on sidewalk in front of church. In album
(disbound): Negro Life in Georgia, U.S.A., compiled and prepared by
W. E. B. Du Bois, v. 4, no. 351.

Reverend Henry Hugh Proctor, pastor of the First Congregational Church, Atlanta
in album (disbound): Types of American Negroes, compiled and prepared by
W. E. B. Du Bois, v. 1, no. 61.

Black Churches and Religion

The Negro Church is the only social institution of the Negroes which started in the African forest and survived slavery; under the leadership of priest or medicine man, afterward of the Christian pastor, the Church preserved in itself the remnants of African tribal life and became after emancipation the center of Negro social life. So that today the Negro population of the United States is virtually divided into church congregations which are the real units of race life.

Report of the Third Atlanta Conference, 1898

In the Exhibit of American Negroes there are photographs of African-American churches included in both the general exhibit and in the Georgia Negro Exhibit. These included photographs of rural churches in Georgia, as well as a thorough survey of African-American churches found in Washington, D.C. In addition, a great deal of documentation about Black churches was provided in works included in the exhibit such as W. E. B. Du Bois's *The Philadelphia Negro* and various volumes of the *Atlanta Reports*.

In *The Philadelphia Negro*, for example, Du Bois describes how the Negro Church preserved many of the functions of the tribal organization and family from Africa. According to him: "Its tribal functions are shown in its religious activity, its social authority and general guiding and coordinating work; its family functions are shown by the fact that the church is a centre of social life and intercourse; acts as a newspaper and intelligence bureau, is the centre of amusements—indeed, is the world in which the Negro moves and acts."

Included among the functions of the Negro Church in order of importance are: "1. The raising of an annual budget. 2. The maintenance of membership. 3. Social intercourse and amusements. 5. The setting of moral standards. 5. Promotion of general intelligence. 6. Efforts for social betterment."

As part of the 1903 *Atlanta Conference Report, The Negro Church*, Du Bois and his co-researcher surveyed approximately "200 Negro laymen of average intelligence, in all parts of the country" about the nature of the churches in their communities. Responses were obtained from Georgia, Alabama, Florida, Louisiana, Mississippi, Texas, North Carolina, South Carolina, Virginia, Kentucky, Tennessee, Arkansas, Colorado, Illinois, and Pennsylvania. When asked: "So far as you have observed what is the present condition of our churches in your community?" they answered:

Very good ..23

Good ...49

Progressing, improving, prosperous ..16

Heavy financial burdens hindering spiritual conditions9

Fair financially, low spiritually; more intelligent3

Not so well attended as formerly, but attendants more devoted2

Good, bad and indifferent ..6

Fair, with vast room for improvement ...13

Well attended, but mostly in financial straights12

Poor, bad; not what they should be ..12

Here and there a sign of improvement ...1

Too much involved with financial efforts ..5

Lack of piety and true missionary spirit; need of earnest preachers2

At a standstill spiritually; not influential enough among the young2

As far as general improvement is concerned,
would say, Congregationalists, the Methodists, then Baptists1

Retrograding spiritually ...4

Can't say, don't know; not answered ..5

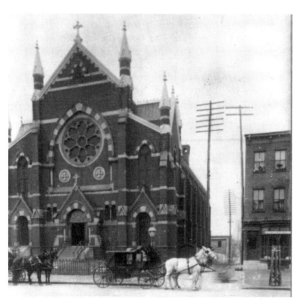

St. Augustine Catholic Church, Washington, D.C.

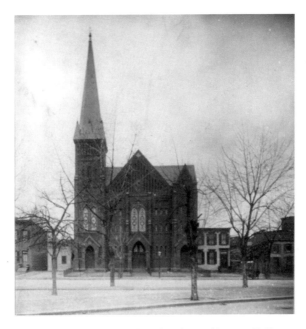

Vermont Avenue Baptist Church, Washington, D.C.
Courtesy of the Library of Congress.

This, and other questions asked by Du Bois and his co-researchers suggests the types of challenges faced by African-American churches at the beginning of the twentieth century. Earlier research by Du Bois and his colleagues at Atlanta University included in the Exhibit provided specific information on individual churches, the resources they had available, the numbers of people attending them, and the types of activities they were engaged in.

For example, in 1898 the Vermont Avenue Baptist Church in Washington, D.C. had enrolled 3,300 members, 1,500 of whom were active on a regular basis. The value of their real estate holdings was $75,000 and their debt $15,000. Five religious meetings were held at the church each week, and fifty "entertainments." Twenty lecturers spoke at the church each year, and five suppers and one fair held annually. Annual income for the church was $4,000 per year, and its expenses $3,500 per year. Expenditures on charity by the church totaled $200.

In 1898, the Fifteenth Street Presbyterian Church in Washington, D.C., had 312 members enrolled with 160 active members. The value of their real estate holdings was $60,000 and their debt $7,000. One religious meeting was held at the church each week, and six "entertainments" per year. Four lecturers spoke at the church each year, and two suppers and one fair held annually. Annual income for the church was $2,000 per year, and its expenses $2,000 per year.

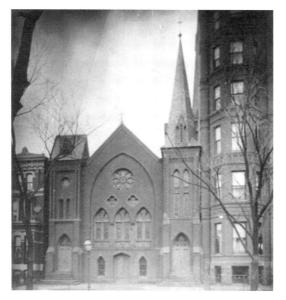

Fifteenth Street Baptist Church, Washington, D.C.

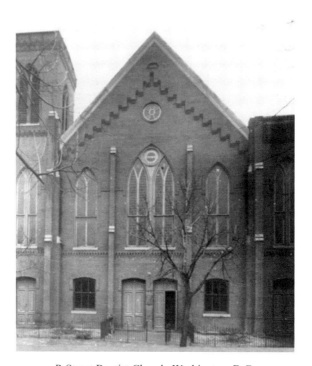

R Street Baptist Church, Washington, D.C.

The churches included in the photographs that were part of the main exhibit were from relatively wealthy and well-established congregations. What is not included are pictures of smaller churches from other parts of the country. The exception to this are the photographs included in the Georgia Negro Exhibit, where the viewer can get a glimpse of people attending church, not only in urban, but also in rural areas.

Among the most interesting photographs of rural churches in Georgia show the arrival of attendees to a large two-story church. A wide age group is included among the attendees. The photographs provide the viewer with a clear image of the types of clothes worn by people attending a service at a rural church, as well as the possible segregation of men from women and young children.

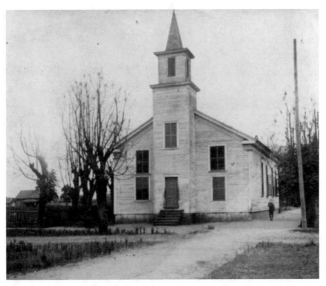

Exterior view of a rural Georgia Church album (disbound): Negro Life in Georgia, U.S.A., compiled and prepared by W. E. B. Du Bois, v. 3, no. 276.

Statistics on these rural churches when compared to their urban counterparts are very revealing. For example, in the 1898 survey of churches compiled by Du Bois and his colleagues there are included statistics on St. Matthew Baptist Church in Petersburg, Virginia, which had 50 members enrolled with 30 active members, $800 worth of real estate holdings and $3 of debt. In Augusta, Georgia, Trinity Church (C.M.E.) had 850 enrolled members, all 850 of whom were reported as being active with a total value of $7,850 in real estate and zero indebtedness. Interestingly, this and many other churches surveyed throughout the South by Du Bois and his colleagues reported no income.

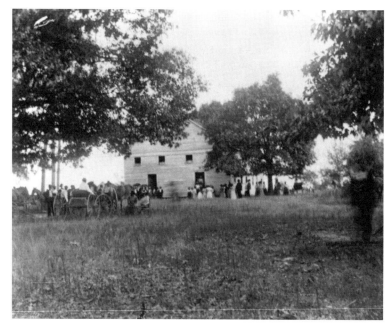

African-Americans arriving at church In album (disbound): Negro Life in Georgia, U.S.A., compiled and prepared by W. E. B. Du Bois, v. 3, no. 273.

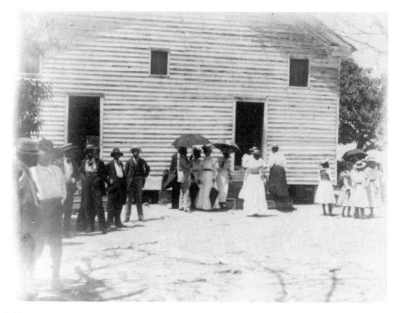

African-Americans standing outside of a church. In album (disbound): Negro Life in Georgia, U.S.A., compiled and prepared by W. E. B. Du Bois, v. 3, no. 277.

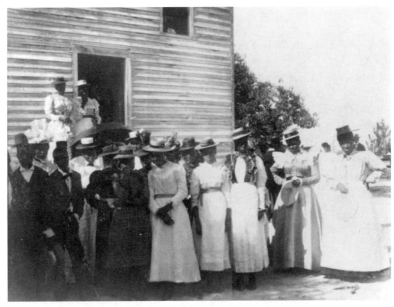

African-Americans posed outside of church. In album (disbound): Negro Life in Georgia, U.S.A., compiled and prepared by W. E. B. Du Bois, v. 3, no. 275.

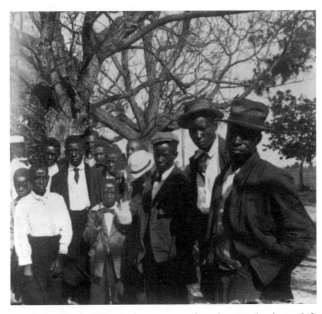

African-American men and boys, three-quarter length portrait, dressed for church, trees in background, album (disbound): Negro Life in Georgia, U.S.A., compiled and prepared by W. E. B. Du Bois, v. 3, no. 269.

NOTES

1. See W. E. B. Du Bois, *The Philadelphia Negro* (New York: Oxford University Press, 2007). Introduction by Lawrence Bobo. Originally published in 1899.

2. See "The Philadelphia Negro," in Phil Zuckerman, editor, *Du Bois on Religion* (Walnut Creek, C.A.: Altamira Press, 2000), p. 32.

3. Ibid., p. 33.

4. Ibid., p. 154.

5. W. E. B. Du Bois, editor, *Some Efforts of American Negroes for Their Own Social Betterment* (Atlanta, G.A.: Atlanta University Press, 1898), pp. 6-7.

6. Ibid., pp. 6-7.

7. Ibid., p. 6.

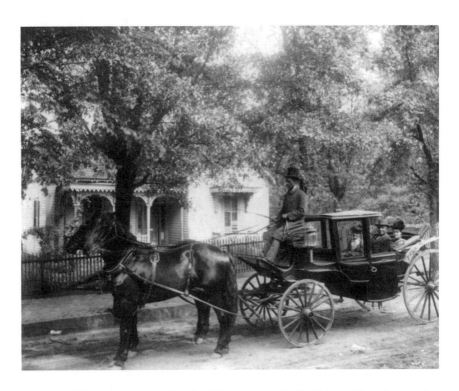

David Tobias Howard, an undertaker, his mother, and wife, Atlanta, Georgia; seated in a horse-drawn carriage with tree-shaded house in background. Du Bois albums of photographs of African-Americans in Georgia.

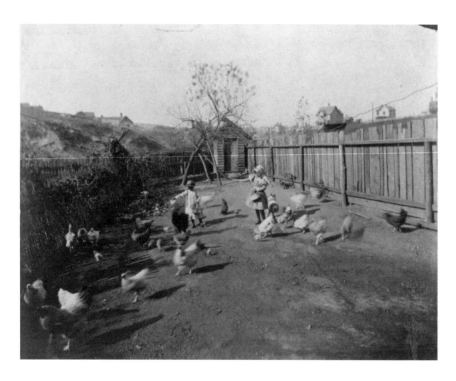

Two African-American children feeding chickens in a fenced-in yard.
Du Bois albums of photographs of African-Americans in Georgia.

Black Homes and Families

Du Bois included a large selection of photographs in the Georgia Negro Exhibit of homes. Most are photographs of exteriors with people occassionally seated on porches or standing by curbsides. Relatively few are of housing in poorer neighborhoods, a subject Du Bois explored in considerable detail in his 1908 Atlanta University Publication #13, Study, *The Negro American Family*.[1] In this work, he explores at length the history of African-American housing going back to Africa and slave quarters prior to Emancipation.

Drawing on census data from 1900, Du Bois describes a total of 1,832,818 private Negro homes in the United States, of which 74% or 1,350,000 are in the "Country districts of the South."[2] According to Du Bois, housing patterns established in slavery—that is, slave quarters with their lack of ventilation, lighting and privacy—set a pattern that continued in the rural areas following Emancipation. As Du Bois explains, in general:

> ...the reign of the one-room cabin was not seriously disputed, and an investigation of a typical black-belt county shows 40% of the families in one room, 43% in two rooms, 10% in threes and 7% in four or more rooms.[3]

Migration out of the rural districts was slow. In 1900, 17.2% of African-Americans, less than one-in-five, lived in towns or cities with populations over 2,500. The Black population was rural, and it was poor.[4] In Southern cities, Du Bois describes the nucleus of home life for Blacks as focusing around the alley.

> It is seen at its worst in the slums of Charleston, Savannah, Washington, and such cities. It represents essentially a crowding—a congestion of population—an attempt to ultilize for dwellings spaces inadequate and unsuited to the purpose, and forms the most crushing indictment of the modern landlord system.[5]

Du Bois sees the alley found in so many Black urban neighborhoods as being "pestilential and dangerous." As he explains:

> The typical alley is a development of the backyard space of two usually decent houses. In the back yard spaces have been crowded little two-room dwellings, cheaply constructed, badly lighted and ventilated, and with inadequate sanitary arrangements, In Atlatna the badly drained and dark hollows of the city are threaded with these alleys, usually unpaved and muddy, and furnishing inviting nests for questionable characters.[6]

In the Exhibit of American Negroes, and more specifically the Georgia Negro Exhibit, Du Bois emphasized photographs of middle-class housing—i.e., models that reflected what he hoped was an emerging "talented tenth," one that could establish standards for the future development of American Blacks. One sees included images of traditional middle-class and professional families, as well as people living in the depths of poverty. In general, the photographs represent a unique record, one which is unprecedented as a documentary source on the conditions of Black homelife and culture at the beginning of the twentieth century.

NOTES

1. *The Negro American Family*, W. E. B. Du Bois, Editor (Atlanta, G.A.: The Atlanta University Press, 1908).

2. Ibid., p. 50.

3. Ibid., p. 53.

4. Ibid., p. 54.

5. Ibid., p. 58.

6. Ibid.

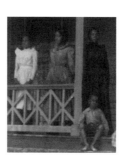
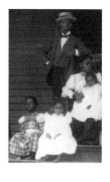

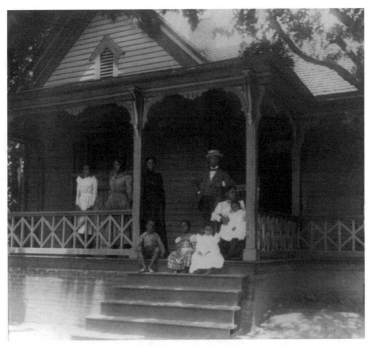

Home of an African-American lawyer, Atlanta, Georgia, with men, women, and children posed on porch of house. In album (disbound): Negro Life in Georgia, U.S.A., compiled and prepared by W. E. B. Du Bois, v. 4, no. 352.

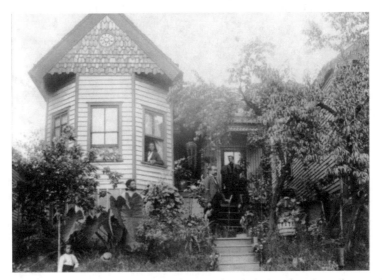

Home of C. C. Dodson, Knoxville, Tennessee. Dodson is the jeweler whose photograph is included in chapter 5, page 33, of this work.

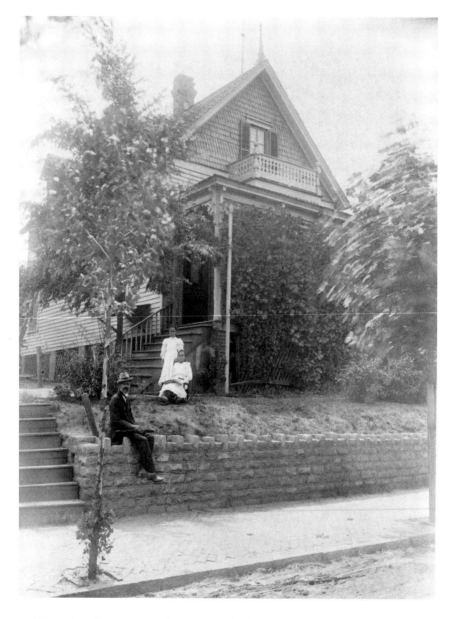

African-American man seated on stone wall and two girls on lawn in front of house in Georgia in album (disbound): Negro Life in Georgia, U.S.A., compiled and prepared by W. E. B. Du Bois, v. 4, no. 349.

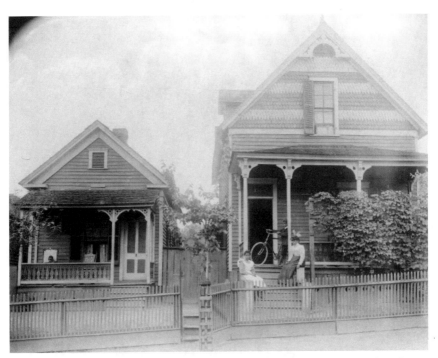

African-American boy seated on porch of house, another African-American boy standing with bicycle on porch of another house, with two young African-American women on steps, Georgia. In album (disbound): Negro Life in Georgia, U.S.A., compiled and prepared by W. E. B. Du Bois, v. 4, no. 339.

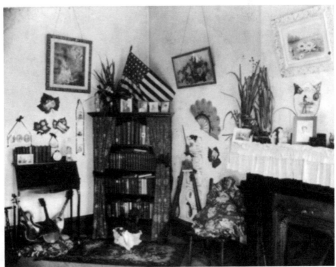

Corner in a Negro teacher's home, New Orleans, Louisiana.

Home of Mr. Nash, Atlanta, Georgia.

Home of R. R. Church, Memphis, Tennessee.

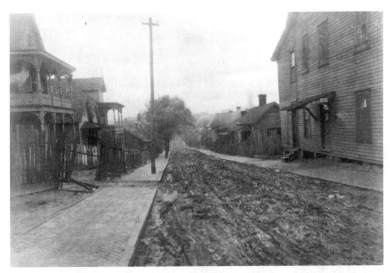

Exterior view of houses along unpaved street in Georgia.

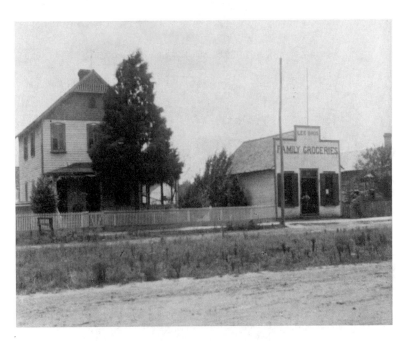

House with picket fence next to "Lee Bros. Family Groceries."
In album (disbound): Negro Life in Georgia, U.S.A., compiled and prepared by
W. E. B. Du Bois, v. 3, no. 248.

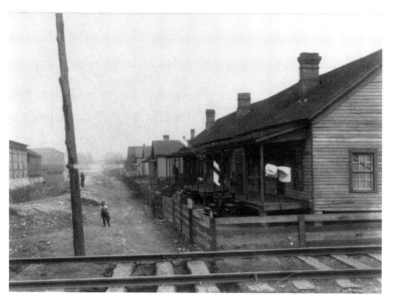

Homes of poorer classes, Chattanooga, Tennessee.

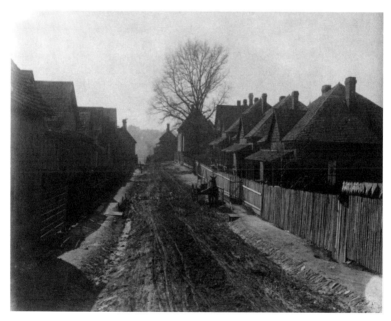

Exterior view of houses along unpaved street in Georgia in album (disbound): Negro
Life in Georgia, U.S.A., compiled and prepared by W. E. B. Du Bois, v. 4, no. 291.

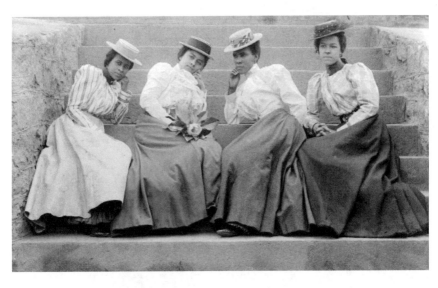

Four African-American women seated on the steps of Atlanta University. Untitled photo in album (disbound): Negro Life in Georgia, U.S.A., compiled and prepared by W. E. B. Du Bois, v. 4, no. 362.

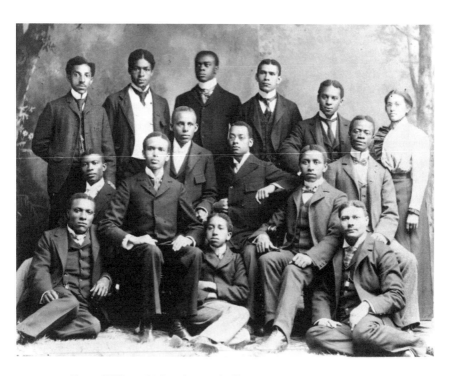

Roger Williams University, Nashville, Tennessee, Academic class.

Black Colleges and Universities

Among the most interesting materials included in the Exhibit of American Negroes were a series of photographs sent by the African-American colleges and universities. Contributions came from over a dozen different schools, including: Hampton Normal and Agricultural Institute, Hampton, Virginia, Tuskegee Normal and Agricultural Institute, Tuskegee, Alabama; Howard University, Washington, D.C, Fisk University, Nashville, Tennessee; Agricultural and Mechanical College, Greensboro, North Carolina; Berea College, Berea, Kentucky; Atlanta University, Atlanta, Georgia; Roger Williams University, Nashville, Tennessee; Central Tennessee College, Nashville, Tennessee; Pine Bluff Normal and Industrial School, Pine Bluff, Arkansas; Haines Normal and Industrial Institute, Augusta, Georgia; and Claflin University, Orangeburg, South Carolina.

The photographs contrast the two major educational models that were at work in African-American higher education at the beginning of the twentieth century. The first, Booker T. Washington's Hampton model (discussed in the introduction to this work along with its counterpoint, Du Bois's model of the Talented Tenth), emphasized industrial over more intellectually and professionally oreiented education. Photographs showing this model can be seen in materials sent by schools such as the Haines Industrial Instiute, but also Tuskegee Normal and Agricultural University, as well Howard University. Institutions such as Fisk emphasized the second model of elite training associated with W. E. B. Du Bois's idea of the Talented Tenth.

Many institutions combined the models. This is true, for example, with Howard University, who sent images of students working in their Pharmaceutical Laboratory and Dentistry program together with photographs of a sewing class. Others such as Claflin University emphasized industrial training.

Many of the photographs depict not only instructional settings, but informal activities including clubs, athletics, and teacher training classes. For example, Howard University included photographs of elementary school students in its "Practice" school and Haines Institute a photograph of its kindergarten program.

Hampton Institute

Among the most interesting photographs sent by the Black colleges and universities to the Exhibit of American Negroes were those from Hampton Institute, which was founded in 1868 by northern philanthropists in Hampton, Virginia. The school's founding principal was General Samuel Chapman Armstrong, who lead the school until his death in 1893. The school, which was neither a government nor a state school, was chartered by a special act of the General Assembly of Virginia and was controlled by a board representing both different regions of the country and various religious groups. The school's most famous graduate was Booker T. Washington.

Hampton was unique in that it opened its doors to Native Americans. Beginning in 1878, Native American students were brought to the school from Northern Plains tribes to be "re-educated." Armstrong, who had been raised by missionary parents in Hawaii, promoted a curriculum which was highly colonialist in its tenor and promoted the most rapid assimilation possible.

The photographs of Hampton for the Exhibit of American Negroes are particularly noteworthy. Taken by Frances Benjamin Johnston, one of the family photographers of President Theordore Roosevelt and one of the leading social and documentary photographers of her period, her pictures emphasized progressive notions of learning by doing.

Johnston's photographs, through an historical accident, made their way to the Museum of Modern Art where they were republished in 1966 as *The Hampton Album: 44 Photographs by Frances B. Johnston from an Album of Hampton Institute,*[1] with an introduction and note on the photographer by Lincoln Kirstein (New York: The Museum of Modern Art, 1966). Many of the images of Hampton exhibited as part of the Exhibit of American Negroes were also included in an April 1900 article by Albert Shaw in the *American Monthly Review of Reviews.*[2] Emphasized in Shaw's article was the role of the type of education provided at Hampton in uplifting Black culture and life. With their inclusion of Native American subjects, they also address issues of cultural diversity and asssimilation.

Hampton Institute.

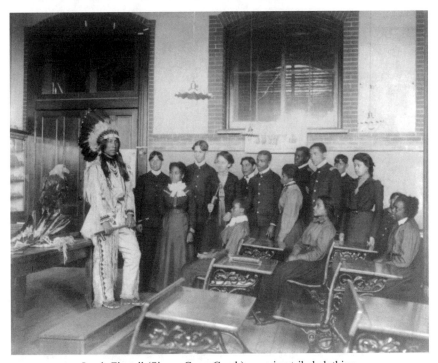

Louis Firetail (Sioux, Crow Creek), wearing tribal clothing,
in American history class.

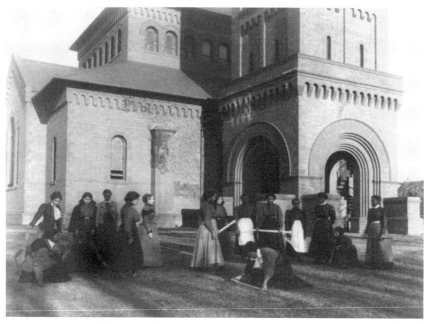

Girls measuring piece of ground in arithmetic class.

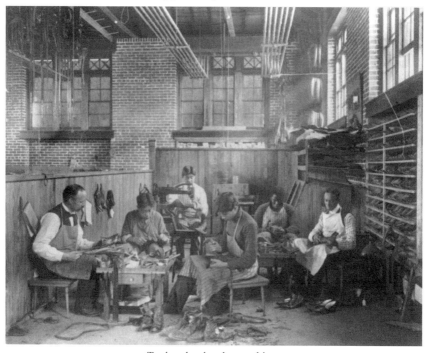

Trade school—shoe making.

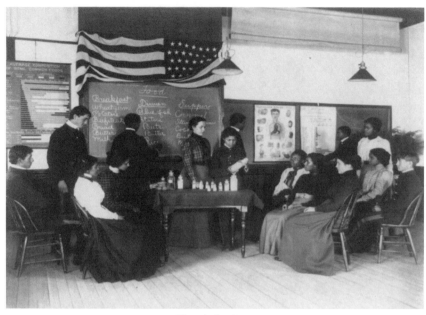

Class in hygiene.

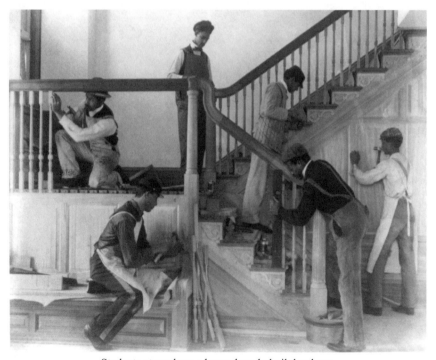

Students at work on a house largely built by them.

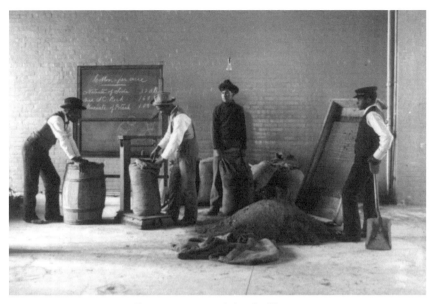

Four young men mixing fertilizers.

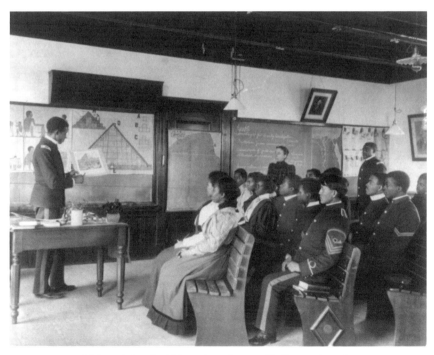

Male and female African-American and Indian students in
Ancient History class studying Egypt.

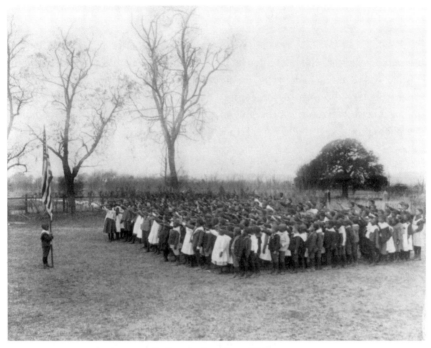

A class in American History.

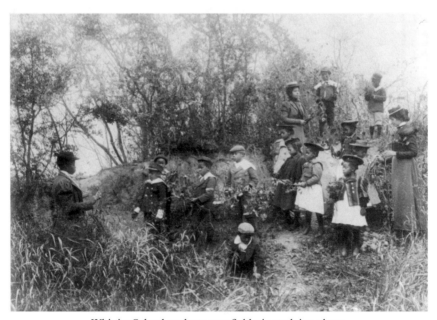

Whittier School students on a field trip studying plants.

Howard University

Washington D.C.'s Howard University was chartered by the federal government in 1867. Named after its first President, General Oliver O. Howard, Howard has as much as any institution been the national university for African-Americans. By the turn of the century, it had developed a strong liberal arts emphasis with preparatory programs in education, theology, law, and medicine. The photographs sent to the Paris Exposition reflect its different programs.

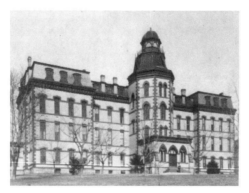

Main Building at Howard University.

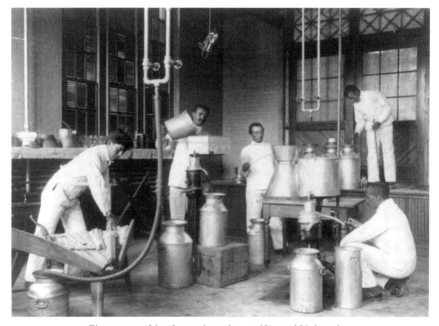

Five men making butter in a class at Howard University.

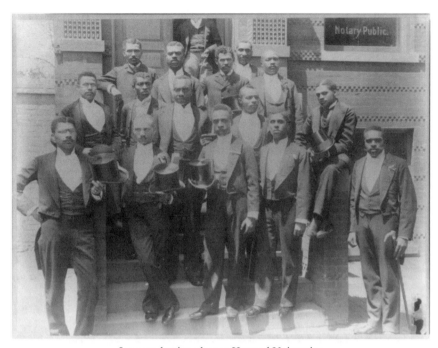

Law graduating class at Howard University.

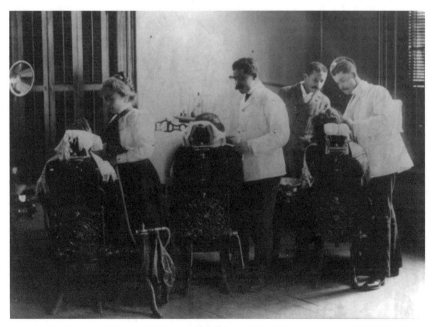

Dentistry.

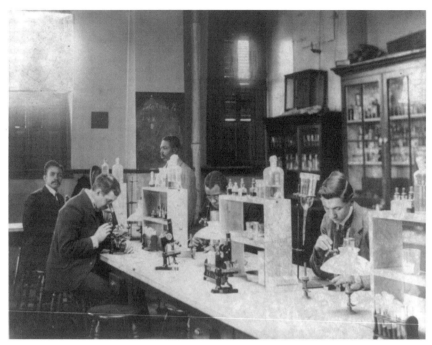

Class in bacteriology laboratory.

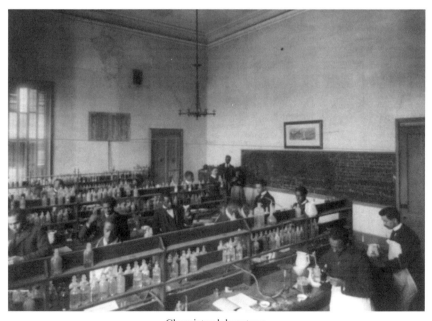

Chemistry laboratory.

Law library.

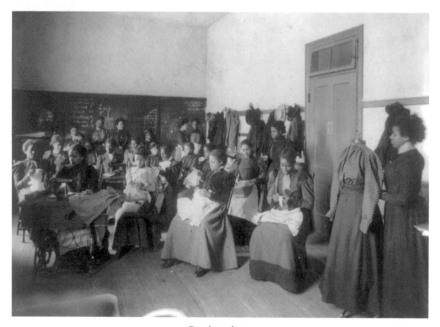

Sewing class.

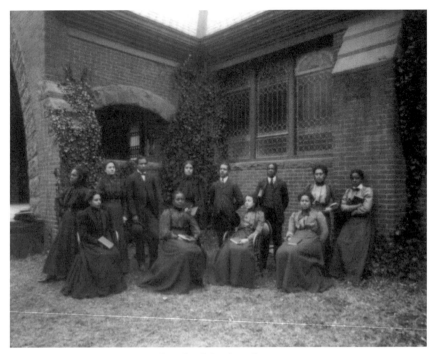

Practice School teachers.

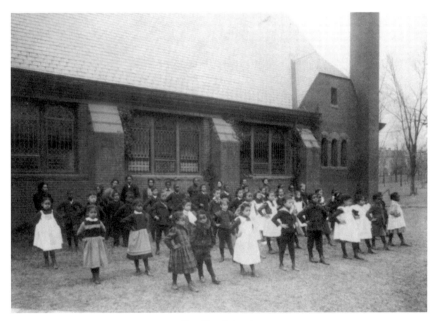

Practice School.

Fisk University

Fisk University was founded in 1806 by the American Missionary Association (Congregational Church) on the site of an abandoned army barracks in Nashville, Tennessee. It was named after General Clinton B. Fisk, who was stationed in Nashville immediately following the Civil War.

Funds for the school were initially raised by sending out a company of student singers known as "The Jubilee Singers." Over a five-year period, the widely acclaimed choir toured the Northern States, Great Britain, and Europe. In doing so, they not only raised the founding endowment for the school, but also made it known around the world.

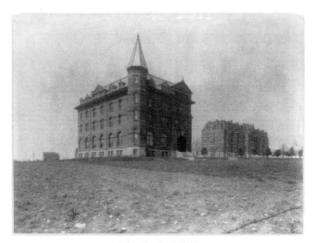

Theological Hall.

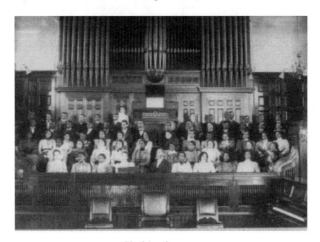

Choir and organ.

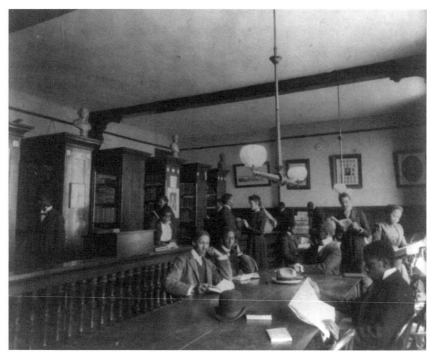

Library.

Group of children from the Model School.

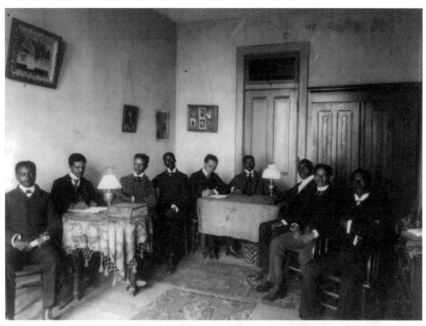

Extempo club .

Calculus class.

Claflin University

Claflin University was founded in 1869 by the Methodist Church. Located in Orangeburg, South Carolina, its early curriculum reflected the manual and industrial training emphasis that was common in many of the historic black colleges at the turn of the century.

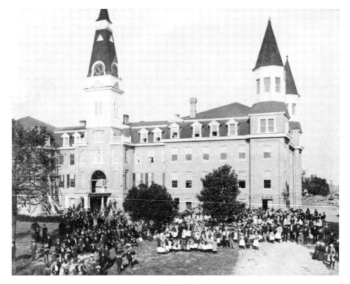

Main building.

Library.

Brass band.

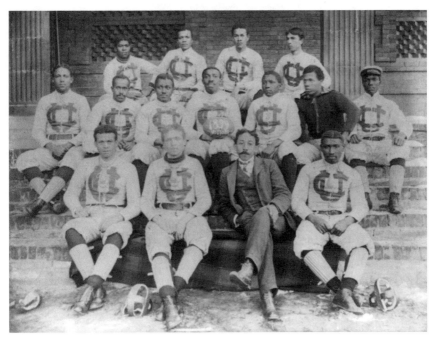

Football team.

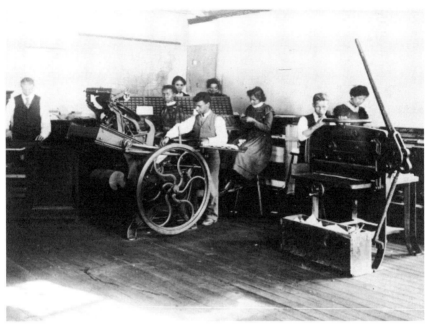

Printing.

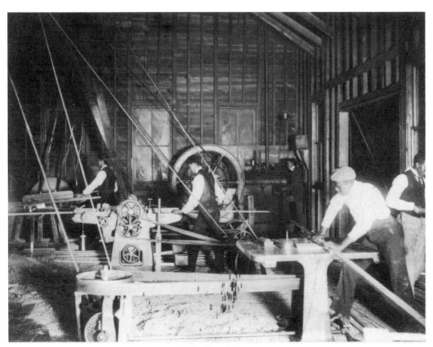

Woodworking.

Carpentry and painting.

Harvesting sweet potatoes.

Additional Schools Exhibting at Paris

Other schools sending materials to the exhibit in Paris included: Berea College, Berea, Kentucky; Roger Williams University, Nashville, Tennessee; Central Tennessee College, Nashville, Tennessee; Pine Bluff Normal and Industrial School, Pine Bluff, Arkansas; and Haines Normal and Industrial Institute, Augusta, Georgia.

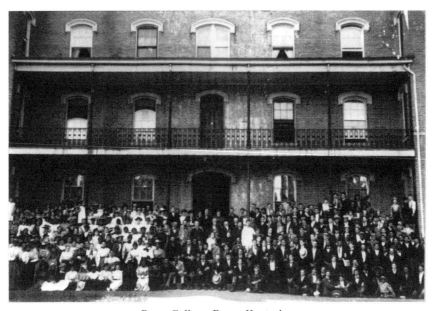

Berea College, Berea, Kentucky.

NOTES

1. *The Hampton Album: 44 Photographs by Frances B. Johnston from an Album of Hampton Institute,* with an introduction and note on the photographer by Lincoln Kirstein (New York: The Museum of Modern Art, 1966).

2. Albert Shaw titled "Learning by Doing' at Hampton", which was published in the April 1900 issue of *The American Monthly Review of Reviews*, pp. 417-432.

African-American woman, head-and-shoulders portrait, facing right. In album (disbound): Types of American Negroes, compiled and prepared by W. E. B. Du Bois, v. 3, no. 204.

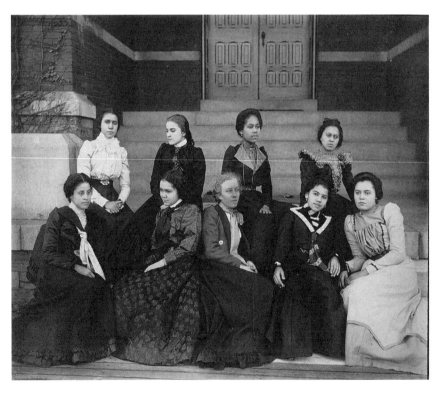

Nine African-American women, full-length portrait, seated on steps of a building at Atlanta University, Georgia. Untitled photo in album (disbound): Negro Life in Georgia, U.S.A., compiled and prepared by W. E. B. Du Bois, v. 4, no. 341.

The Georgia Negro Exhibit (Part I) Charts and Graphs Showing the Social and Economic Condition of Georgia Since Emancipation

While W. E. B. Du Bois helped contribute to the overall development of the Exhibit of American Negroes, including the mounting of the exhibit, his most important contribution to the project was the creation of the Georgia Negro Exhibit. Put together by Du Bois and his students at Atlanta University, the Exhibit had three parts: 1. Charts and graphs showing the social and economic conditions of Georgia Blacks since Emancipation; 2. four albums of photographs including three albums titled Types of American Negroes, Georgia, U.S.A. (Volumes I-III) and an album titled Negro Life in Georgia (Volume IV); and 3. a handwritten compilation of "Laws Affecting Georgia Blacks from the Colonial Period to 1900."[1]

The charts included in The Georgia Negro Exhibit were described in the *Report of the Commissioner-General for the United States of the International Exposition*, Paris 1900 as consisting:

> ...of a series of charts showing the condition of the colored race in the State of Georgia. This State was selected as being the one with the largest negro population. These charts showed the first general distribution of the negro race in all parts of the world, then the distribution in the United States by states and finally conditions in Georgia in great detail. These latter charts indicated the growth of the Negro population in the State by decades; its relative increase in the comparison with that of the white race; migration to and from the State; the distribution of the negroes according to age, sex, and the conjugal condition; the occupations of the negroes; the number who could read and write; the value of property owned by negroes; the number of acres owned by them or being cultivated by them as owners or tenants; the value of the farm implements, horses, and stock owned, etc. [2]

As outlined above, the charts were one of three parts of the exhibit that Du Bois and his students assembled. They are remarkable in terms of their design,

as well as the information that they contain concerning the conditions of African-American life and culture in Georgia at the beginning of the twentieth century.

A total of fifty-eight charts were included in the Exhibit. Hand colored by Du Bois and his students, they provided an enormous amount of statistical data on the condition of African-Americans in the United States, and more specifically in Georgia. Most of the information for the charts was drawn from sources such as the United States Census, the Atlanta University Reports, and various governmental reports that had been compiled by Du Bois for groups such as the United States Bureau of Labor.

The sociological charts included as part of the Exhibit of the Georgia Negro represents a remarkable compilation of sociological data. It closely parallels the type of scientific study that Du Bois applied to the issue of race in works such as his 1899 study *The Philadelphia Negro,* as well as his *Atlanta University Studies.* It represents the foundations of the modern study of race as a sociological phenomenon in the United States.

The charts measured twenty-three by thirty inches. They were carefully designed—color being added for emphasis. In the following section we have reproduced the charts in black and white. Unfortunately, it was not practical to reproduce the charts in their original color format. The charts are very fragile and excepting for one or two examples have not been rephotographed in color by the Library of Congress's Prints and Photographs Division. The images for this book were made from microfilm reproductions of the charts available through the Library of Congress. Wherever possible, the editor has provided brief descriptions and annotations to help interpret the charts and the materials that they include. These annotations draw on information from the charts themselves, as well as additional data from government and census reports.

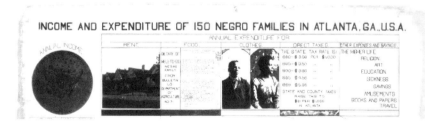

Detail from Chart No. 31, Georgia Negro Exhibit, Negro Population of Georgia by Counties, 1890, Georgia Negro Exhibit, Exhibit of the American Negro, Paris 1900.

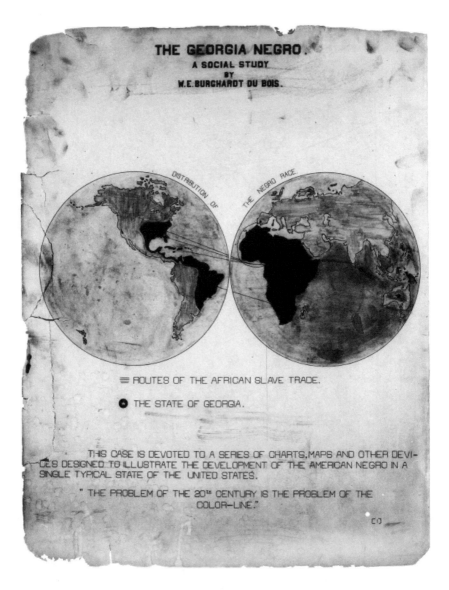

Chart No. 1. The Georgia Negro. A Social Study. At the base of the page is the quote: "THE PROBLEM OF THE TWENTIETH CENTURY IS THE PROBLEM OF THE COLOR LINE."—certainly the most important quote from *The Souls of Black Folk* and perhaps the most significant single quote in African-American history. The declaration was first publicly made by Du Bois while attending the Pan-African Association's conference in London in July of 1900 where he made the address "To the Nations of the World."[3] Immediately following this conference Du Bois went on to Paris to mount the Exhibit of American Negroes.

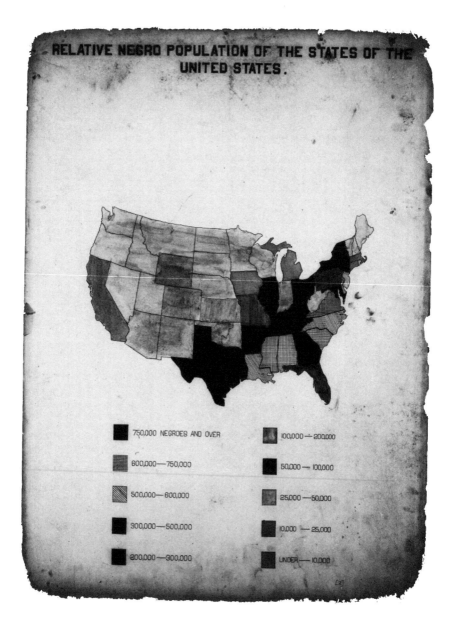

Chart No. 2. Relative Negro Population of the United States.

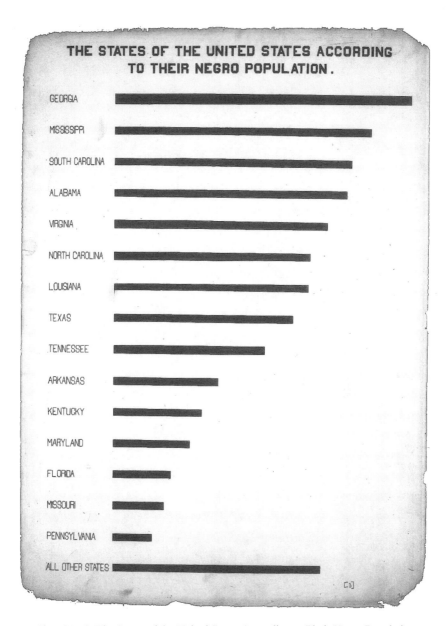

Chart No. 3. The States of the United States According to Their Negro Population.

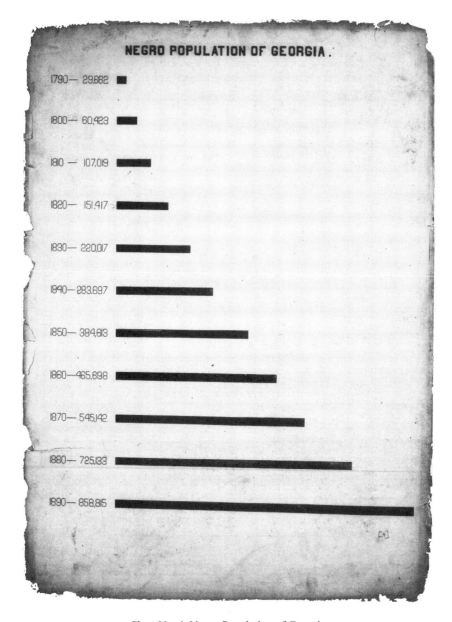

Chart No. 4. Negro Population of Georgia.

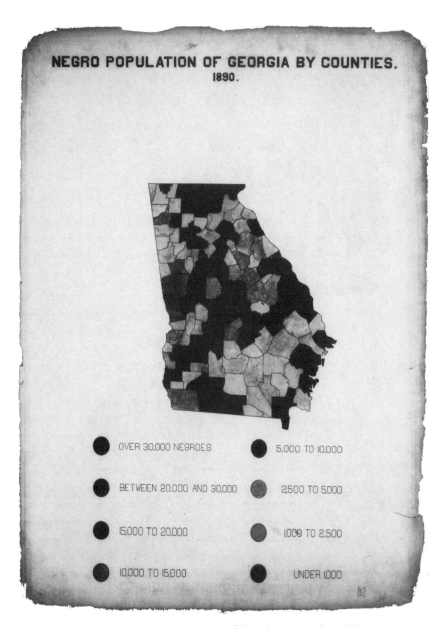

Chart No. 5. Negro Population of Georgia by Counties, 1890.

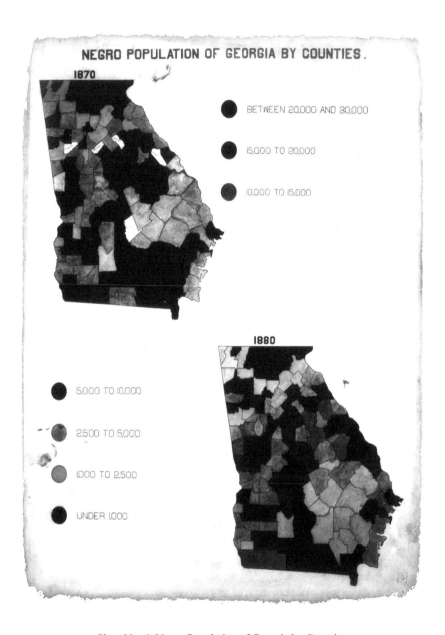

Chart No. 6. Negro Population of Georgia by Counties.

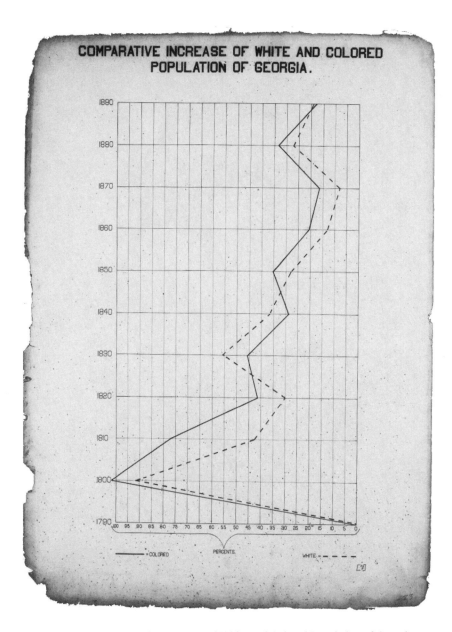

Chart No. 7. Comparative Increase of White and Colored Population of Georgia.

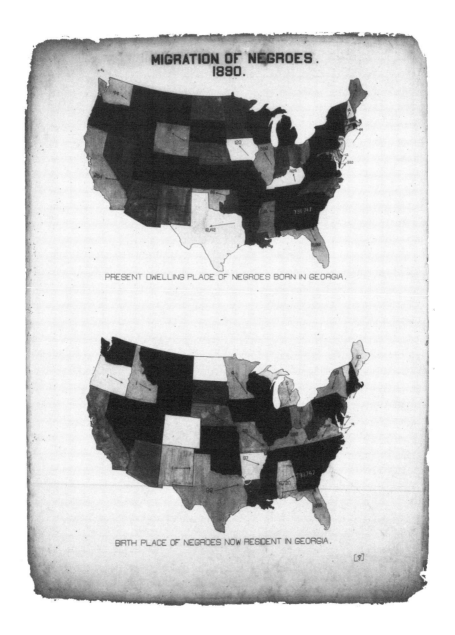

Chart No. 8. Migration of Negroes 1890.

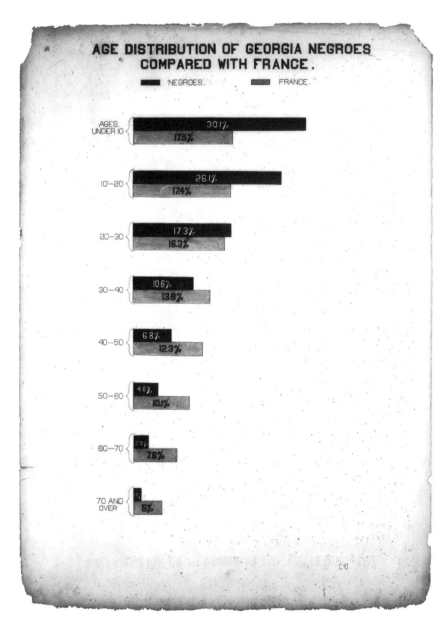

Chart No. 9. Age Distributon of Georgia Negroes Compared with France.

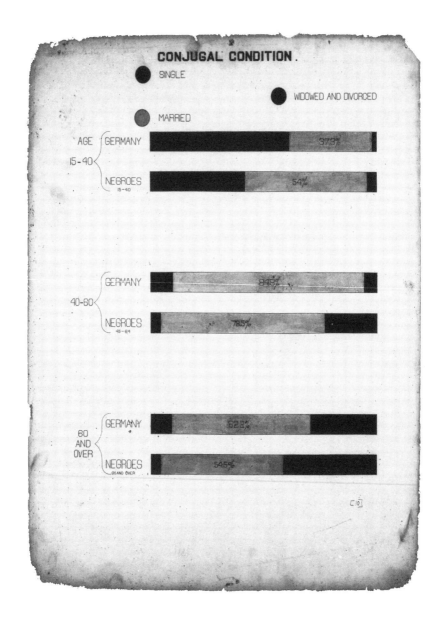

Chart No. 10. Conjugal Condition.

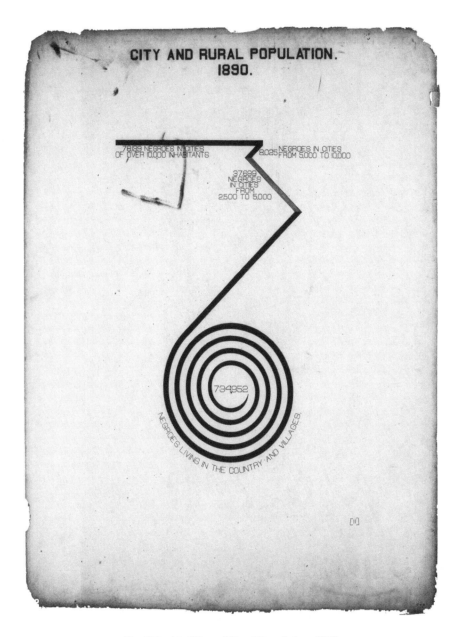

Chart No. 11. City and Rural Population, 1890.

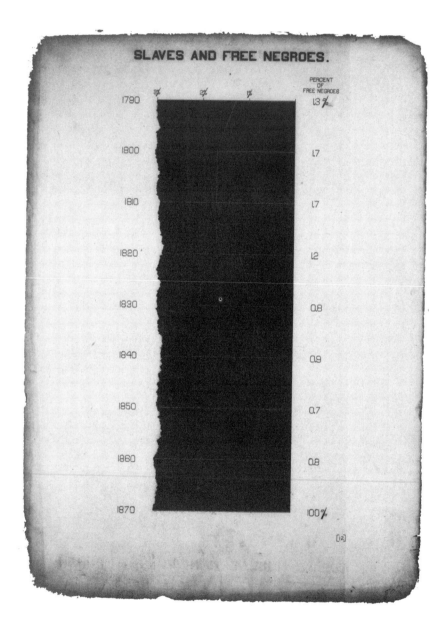

Chart No. 12. Slaves and Free Negroes.

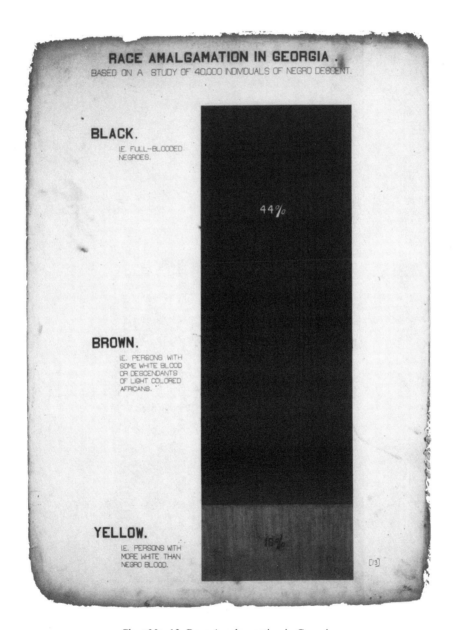

Chart No. 13. Race Amalgamation in Georgia.

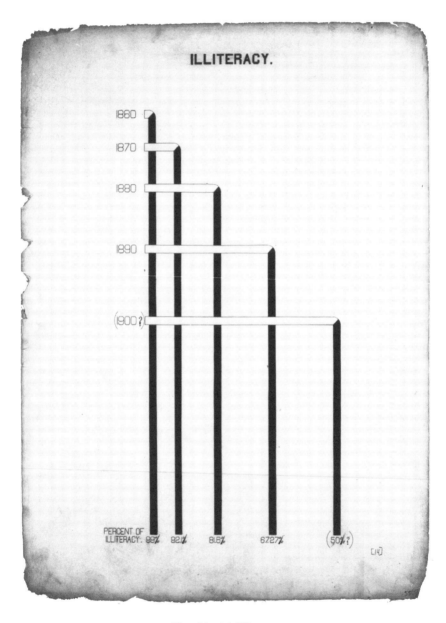

Chart No. 14. Illiteracy.

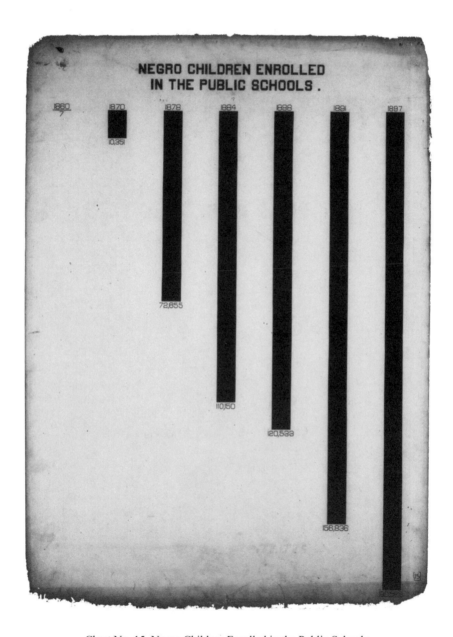

Chart No. 15. Negro Children Enrolled in the Public Schools.

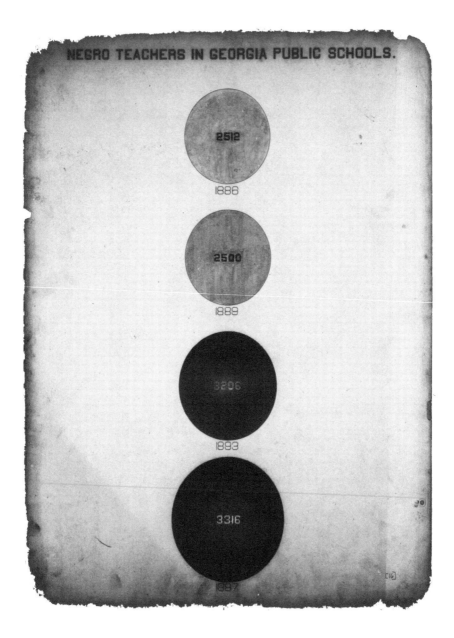

Chart No. 16. Negro Teachers in Georgia Public Schools.

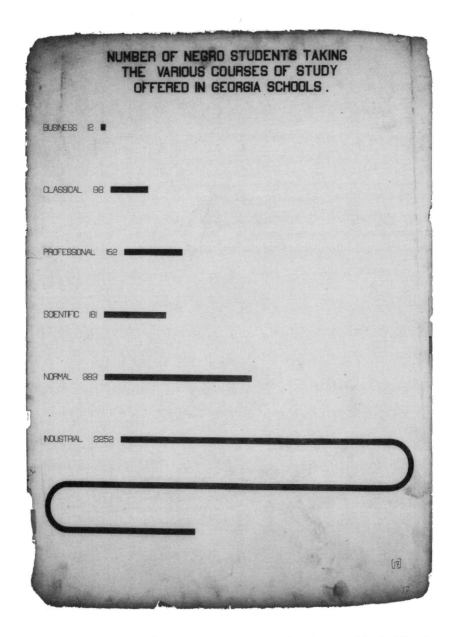

Chart No. 17. Number of Negro Students Taking the Various Courses of Study Offered in Georgia Schools.

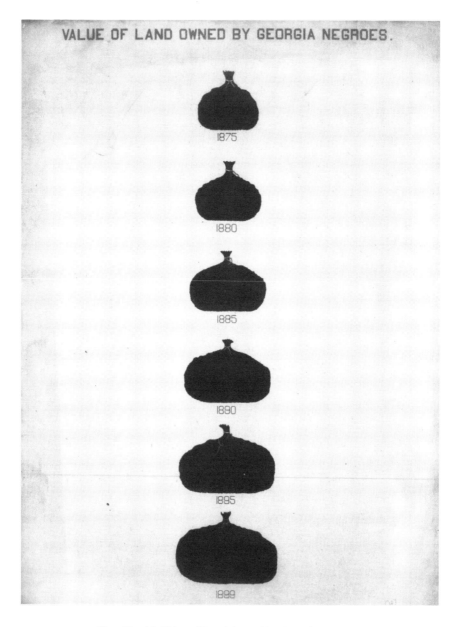

Chart No. 18. Value of Land Owned by Georgia Negroes.

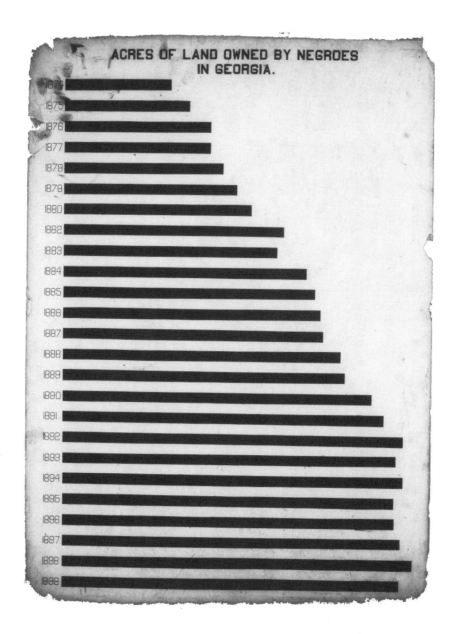

Chart No. 19. Acres of Land Owned by Negroes in Georgia.

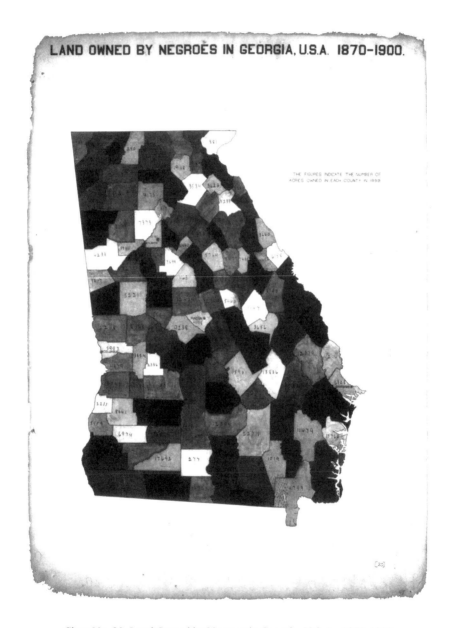

Chart No. 20. Land Owned by Negroes in Georgia, U.S.A., 1870-1900.

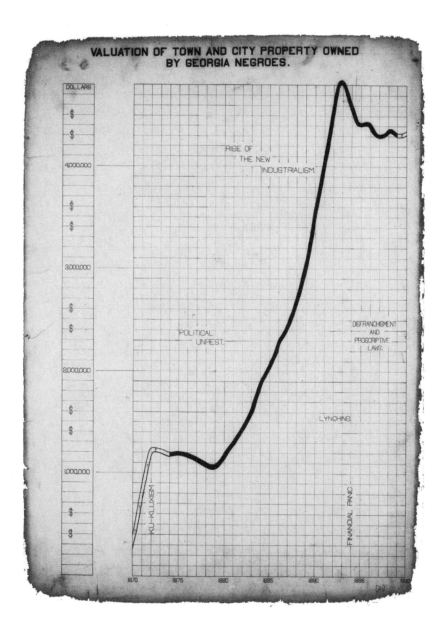

Chart No. 21. Valuation of Town and City Property Owned by Georgia Negroes.

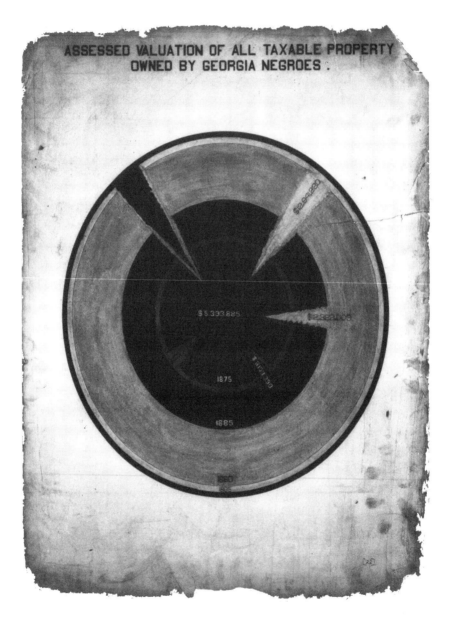

Chart No. 22. Assessed Valuation of All Taxable Property Owned by Georgia Negroes.

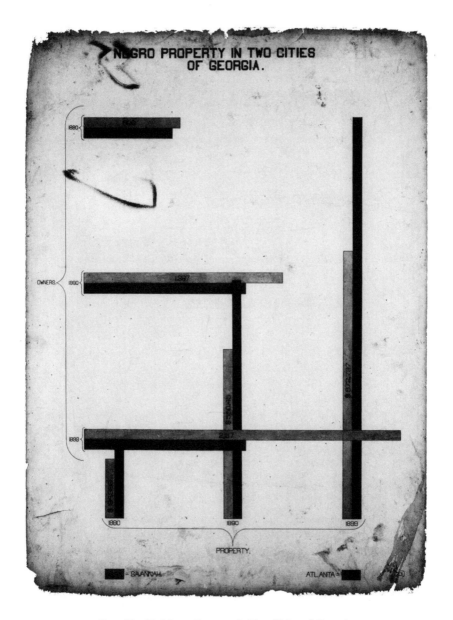

Chart No. 23. Negro Property in Two Cities of Georgia.

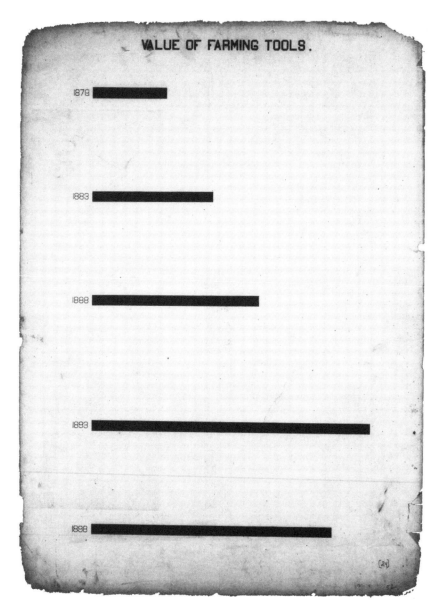

Chart No. 24. Value of Farming Tools.

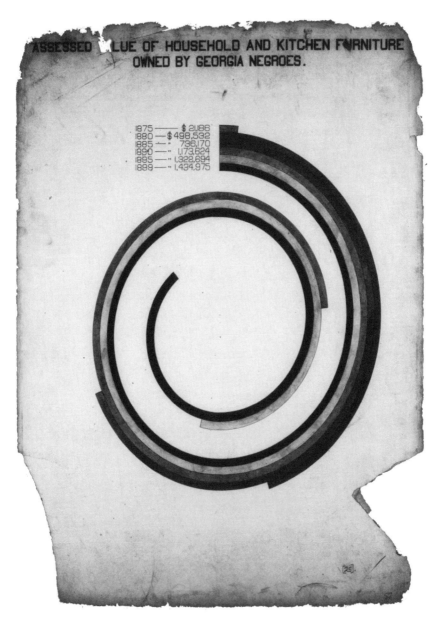

Chart No. 25. Assessed Value of Household and Kitchen Furniture Owned by Georgia Negroes.

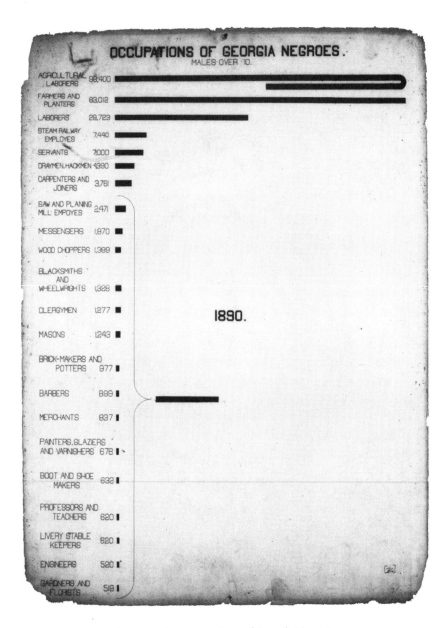

Chart No. 26. Occupations of Georgia Negroes.

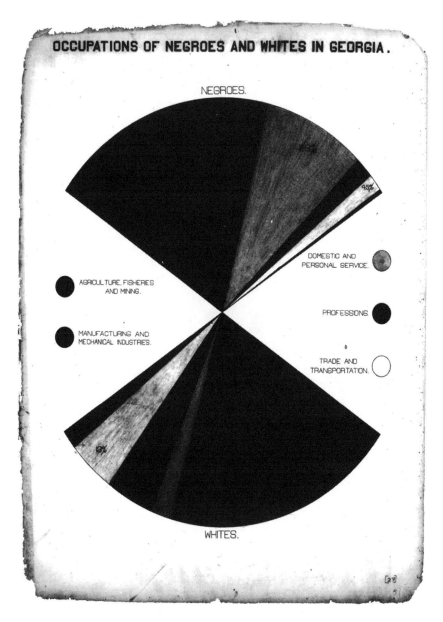

Chart No. 27. Occupations of Negroes and Whites in Georgia.

Chart No. 28. Occupations and Incomes.

Chart No. 29. Occupations and Income [of Negroes].

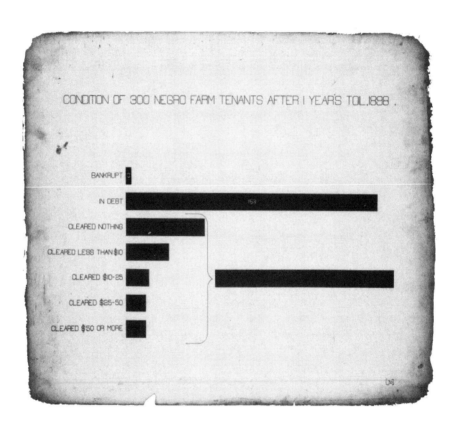

Chart No. 30. Condition of 300 Negro Farm Tenants After 1 Years to 1898.

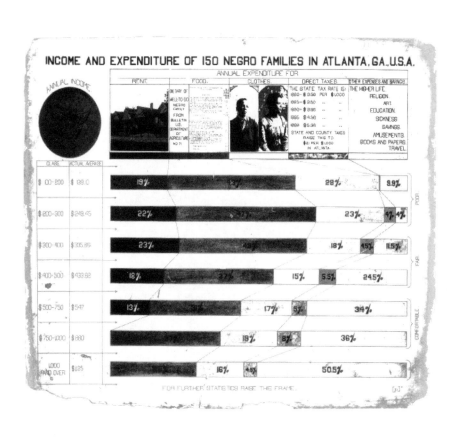

Chart No. 31. Income and Expenditure of 150 Negro Families in Atlanta, GA., USA.

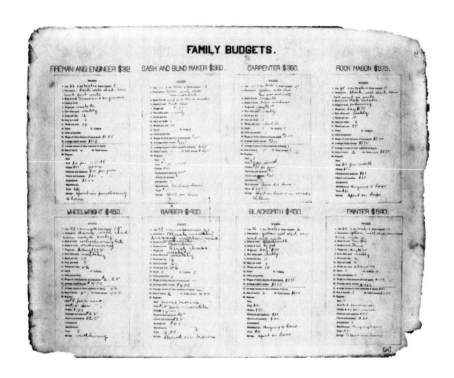

Chart No. 32. Family Budgets.

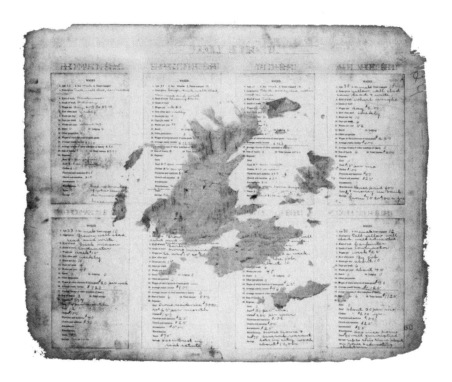

Chart No. 33. Family Budgets.

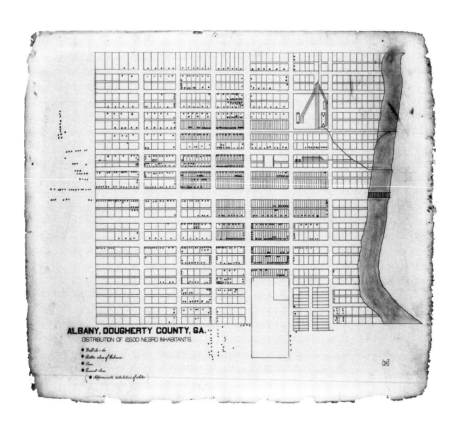

Chart No. 34. Albany, Dougherty County, Georgia.

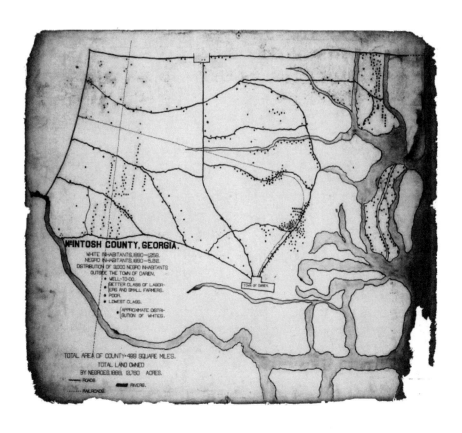

Chart No. 35. McIntosh County, Georgia.

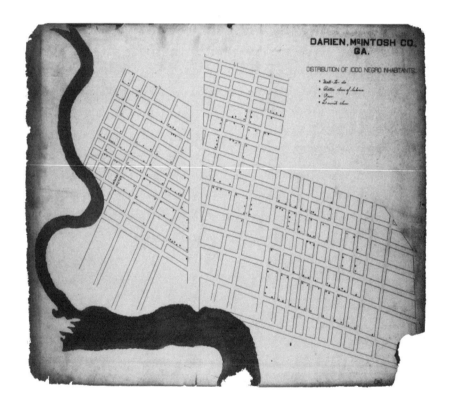

Chart No. 36. Darien, McIntosh County, Georgia.

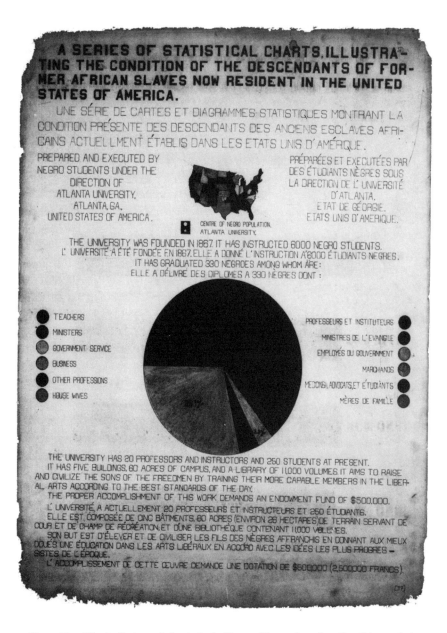

Chart No. 37. A Series of Statistical Charts Illustrating the Condition of the Descendants of Former African Slaves Now Resident in the United States of America.

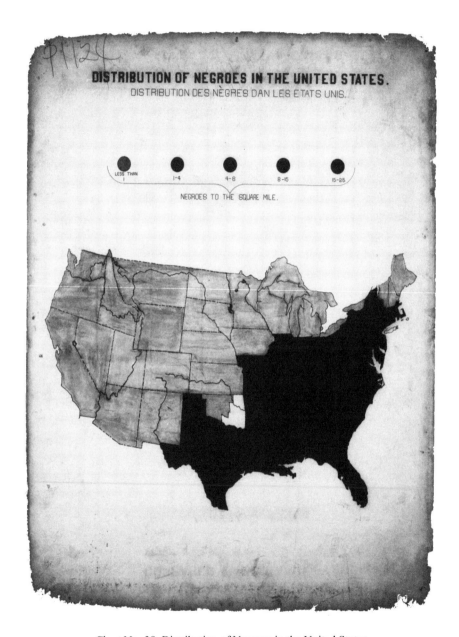

Chart No. 38. Distribution of Negroes in the United States.

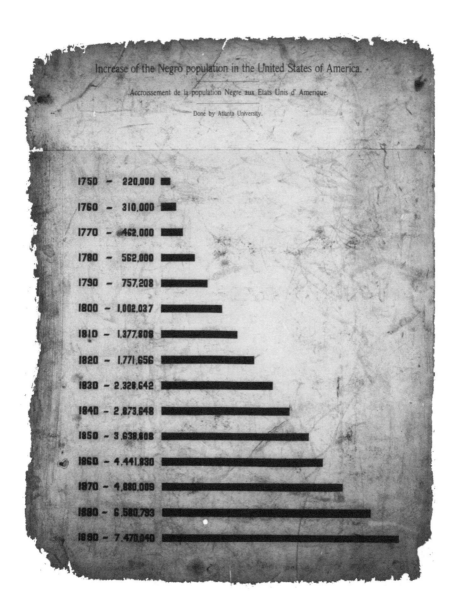

Chart No. 39. Increase of the Negro Population in the United States of America.

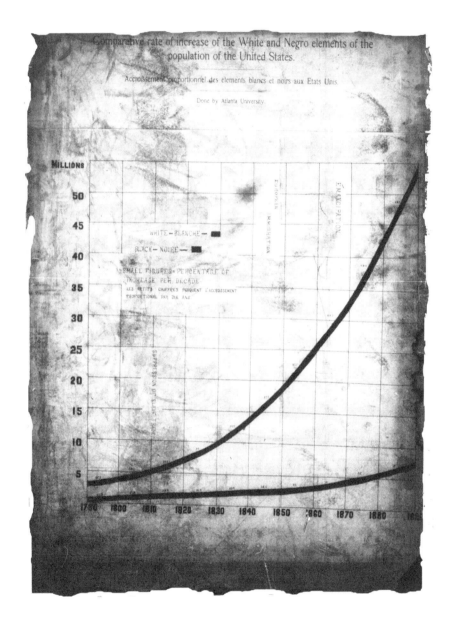

Chart No. 40. Comparative Rate of Increase of the White and Negro Elements of the
Population of the United States.

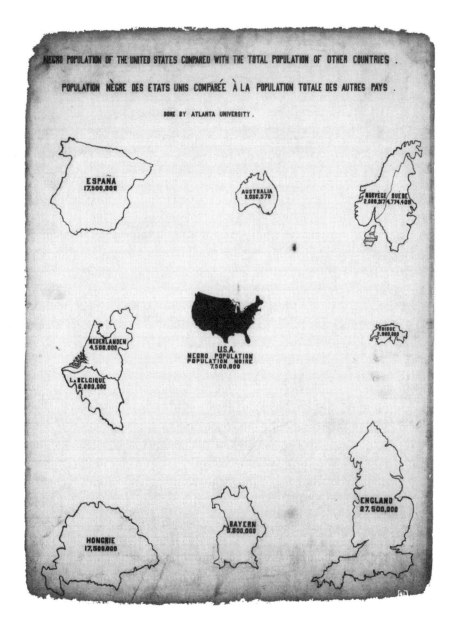

Chart No. 41. Negro Population of the United States Compared with Total Population of Other Countries.

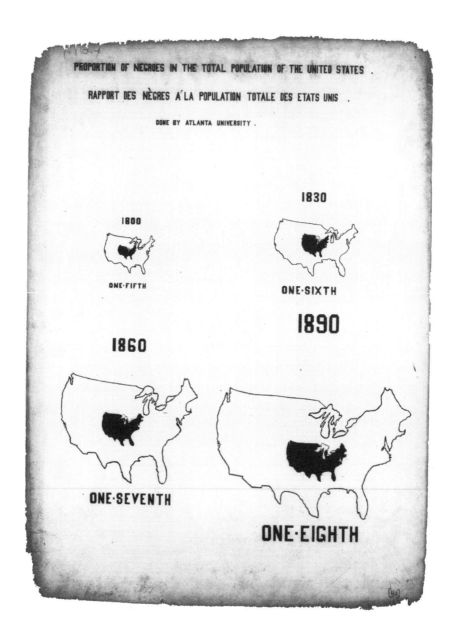

Chart No. 42. Proportion of Negroes in the Total Population of the United States.

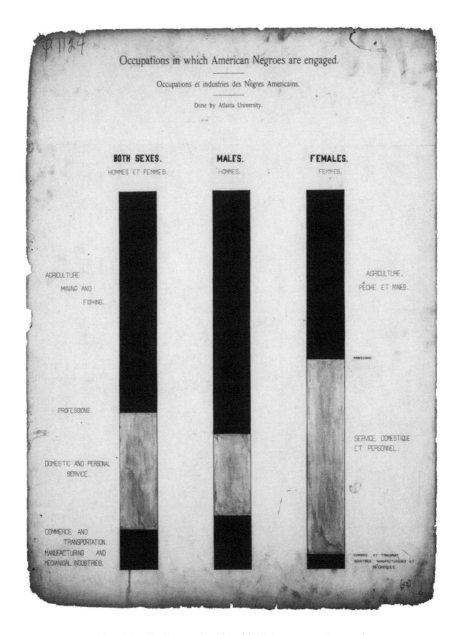

Chart No. 43. Occupations in which Negroes are Engaged.

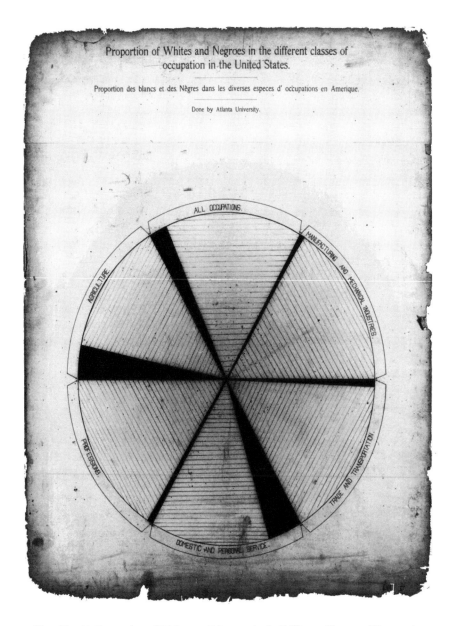

Chart No. 44. Proportion of Whites and Negroes in the Different Classes of Occupation in the United States

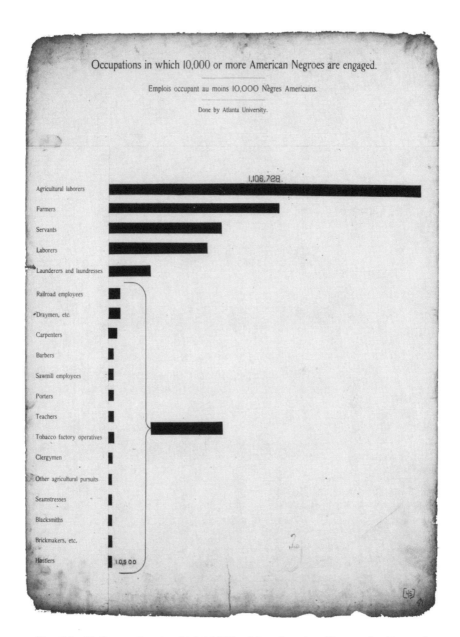

Chart No. 45. Occupations in which 10,000 or More American Negroes Are Engaged.

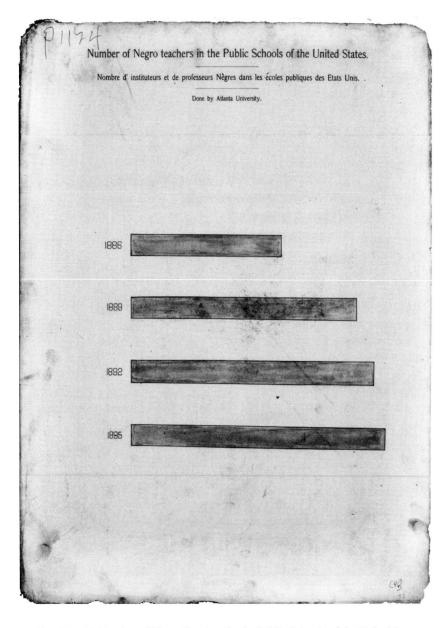

Chart No. 46. Number of Negro Teachers in the Public Schools of the United States.

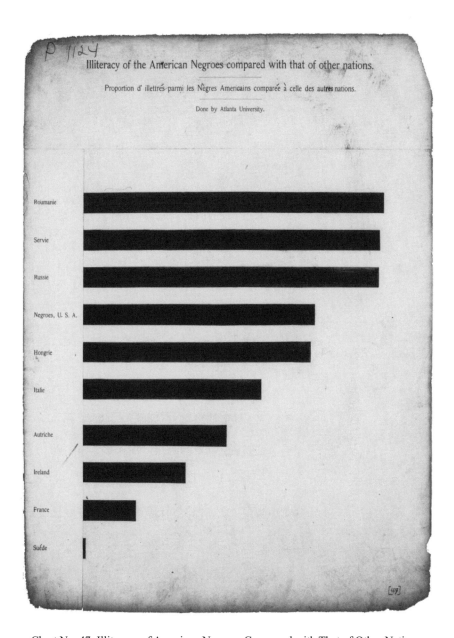

Chart No. 47. Illiteracy of American Negroes Compared with That of Other Nations.

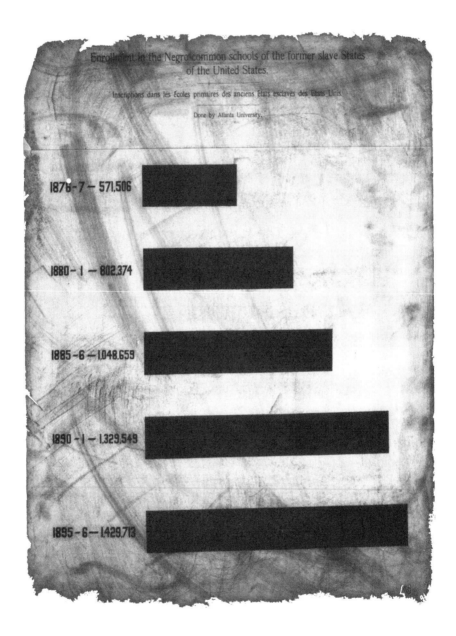

Enrollment in the Negro common schools of the former slave States
of the United States.

Inscriptions dans les écoles primaires des anciens états esclaves des États Unis.

Done by Atlanta University.

1876-7 — 571,506

1880-1 — 802,374

1885-6 — 1,048,659

1890-1 — 1,329,549

1895-6 — 1,429,713

Chart No. 48. Enrollment in the Negro Common Schools of the Former Slave States.

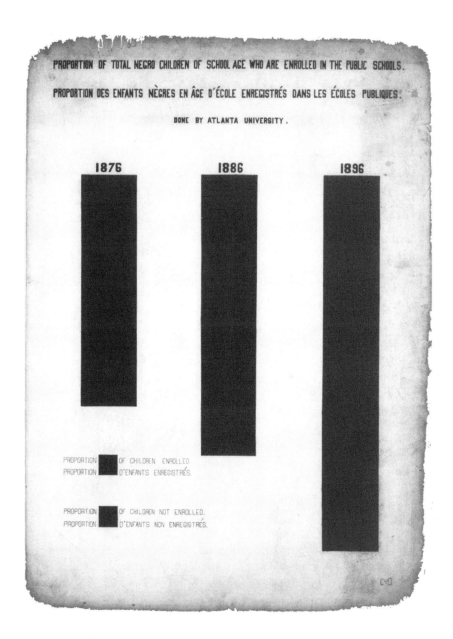

Chart No. 49. Proportion of Total Negro Children of School Age Who Are Enrolled in the Public Schools.

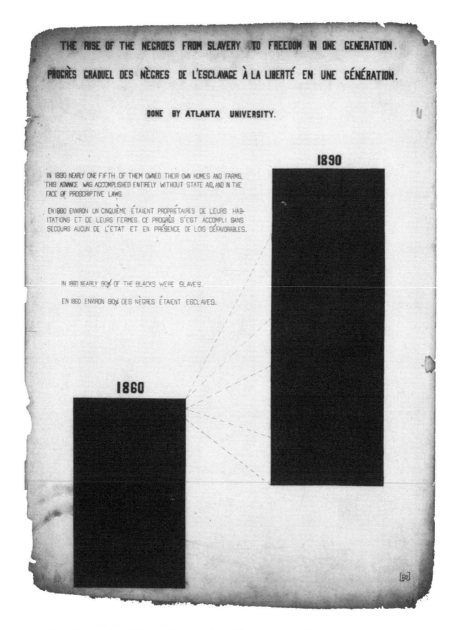

Chart No. 50. The Rise of Negroes from Slavery to Freedom in One Generation.

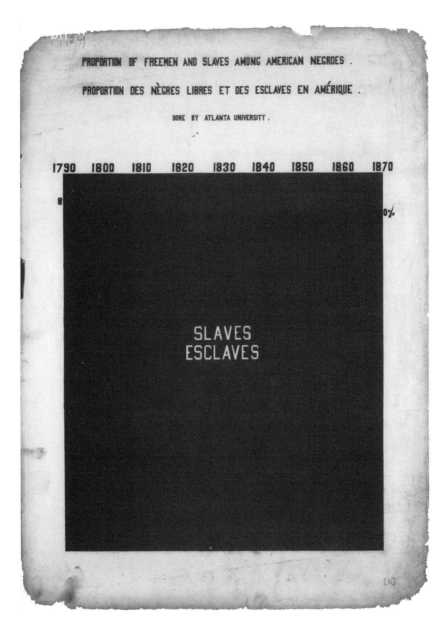

Chart No. 51. Proportion of Freemen and Slaves among American Negroes.

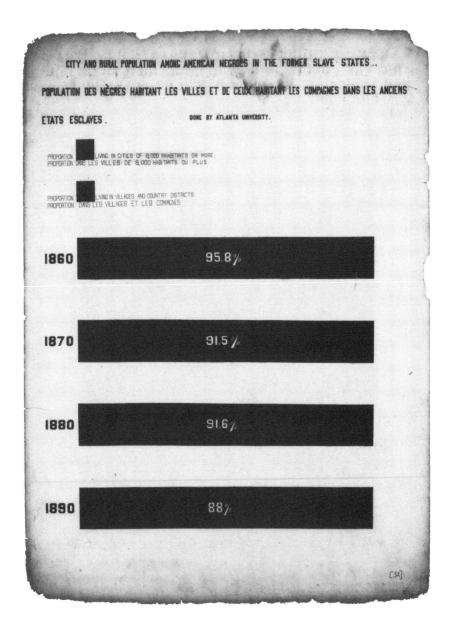

Chart No. 52. City and Rural Population among American Negroes in the Former Slave States.

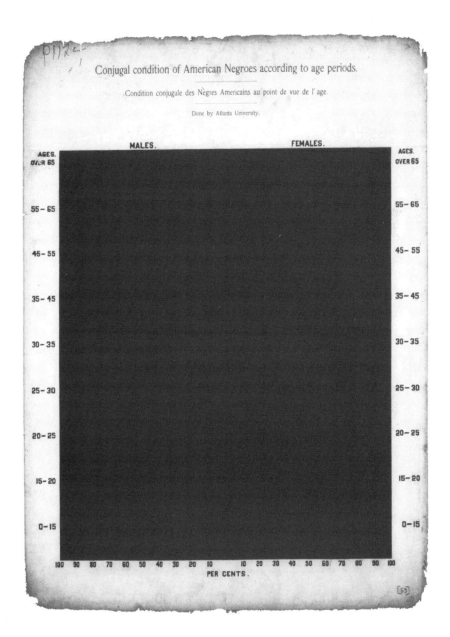

Chart No. 53. Conjugal Condition of American Negroes according to Age Periods.

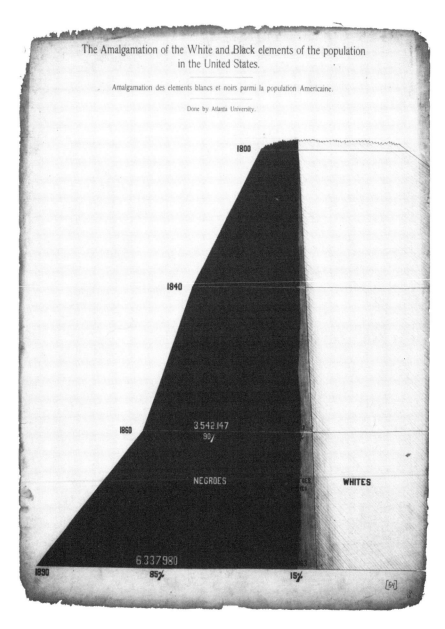

Chart No. 54. The Amalgamation of the White and Black Elements of the Population
in the United States.

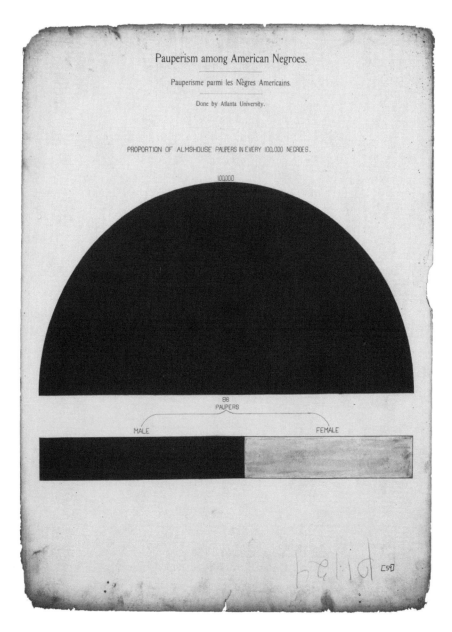

Chart No. 55. Pauperism among American Negroes.

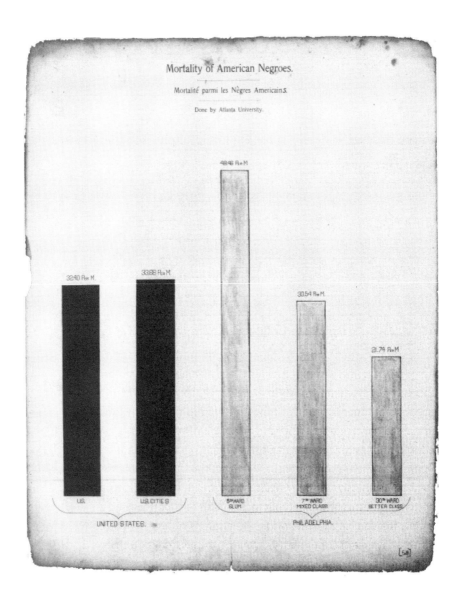

Chart No. 56. Mortality of American Negroes.

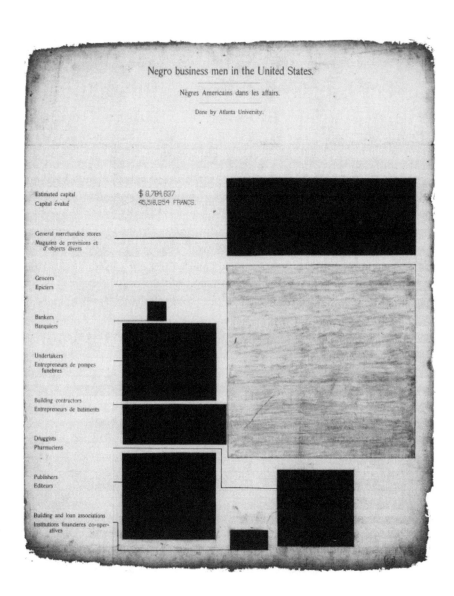

Chart No. 57. Negro Business Men in the United States.

Chart No. 58. Negro Landholders in Various States of the United States.

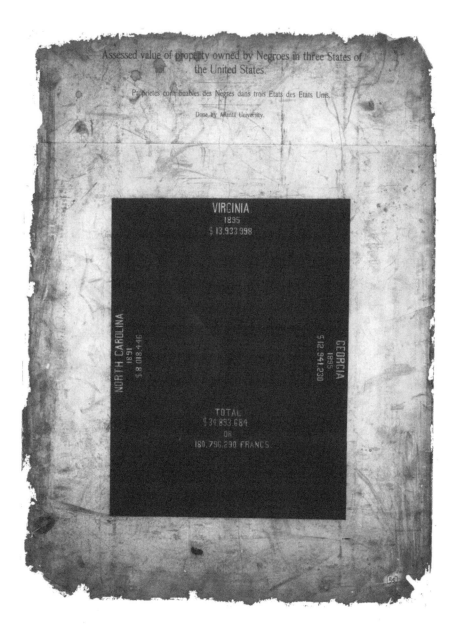

Chart No. 59. Assesed Value of Property Owned by Negroes in three States of the United States.

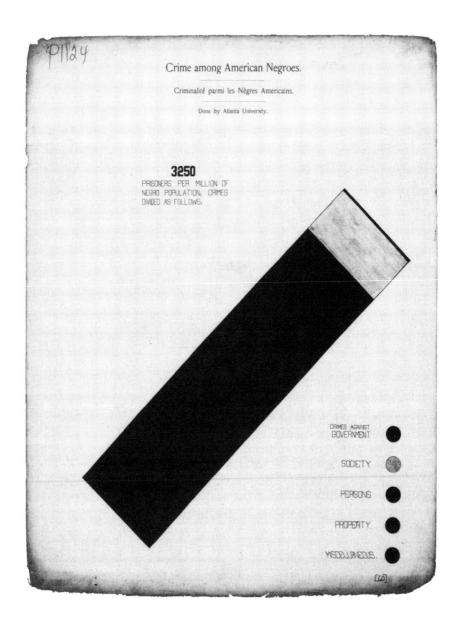

Chart No. 60. Crime among American Negroes.

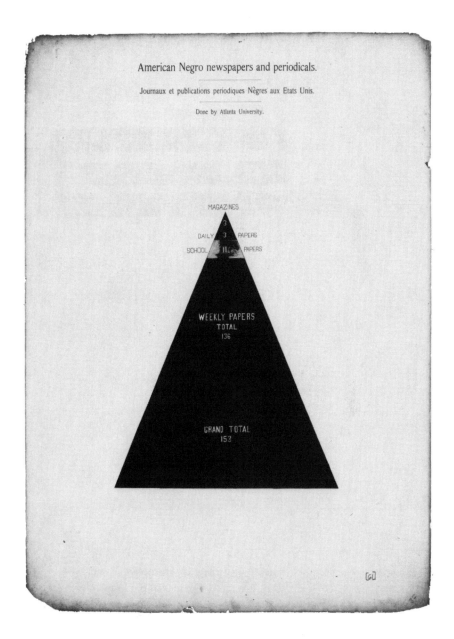

Chart No. 61. American Negro Newspapers and Periodicals.

Chart No. 62. Religion of African Negroes.

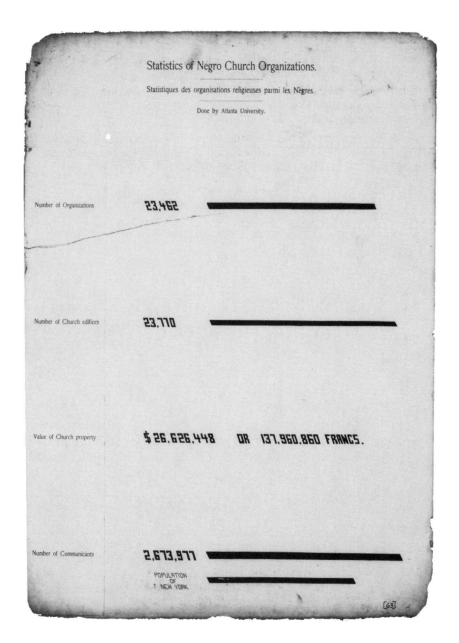

Chart No. 63. Statistics of Negro Church Organizations.

NOTES

1. W. E. B. Du Bois, compiler, *Types of American Negroes, Georgia, U.S.A.* (Volumes I-III),. 1900. Daniel Murray Collection, Library of Congress.

2. "The Negro Exhibit," in the *Report of the Commissioner-General for the United States of the International Exposition, Paris 1900* (Washington, D.C.: U.S. Government Printing Office, 1901), p. 408.

3. See: *Report of the Pan-African Conference, held on 23rd, 24th, and 25th July 1900, at Westminister Town Hall, Westminister, S. W.* [London]. Headquarters 61 and 62, Chancery Lane, W.C., London, England [1900], pp. 10-12.

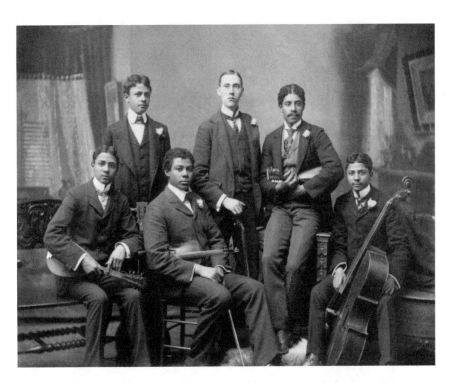

Six young men posed with their instruments in the photographer Thomas Askew's home studio on Summit Avenue, Atlanta, Georgia. From left: the photographer's twin sons Clarence and Norman Askew, son Arthur Askew, neighbor Jake Sansome, and sons Robert and Walter Askew. Included in an album (disbound): Negro Life in Georgia, U.S.A., compiled and prepared by W. E. B. Du Bois, v. 4, no. 356.

African-American woman, half-length portrait, facing slightly right. In album
(disbound): Negro Life in Georgia, U.S.A., compiled and prepared by
W. E. B. Du Bois, v. 2, no. 143.

The Georgia Negro Exhibit (Part II)

Photographic Albums of Types of American Negroes, Georgia, U.S.A., Volumes I-IV

The Georgia Negro Exhibit included four volumes of photographs presented in three separate albums. The pictures are not captioned, nor is the photographer(s) who took them identified. Du Bois does not provide any commentary for the images. Nonetheless there is an important visual text at work in the images he collected together. In the first two volumes there are included several hundred paired studio portraits of African-Americans. They are followed by a collection of well over one hundred photographs depicting Negro life in Georgia. Shawn Michelle Smith has argued that Du Bois in presenting these portraits "was not simply offering images of African-Americans up for perusal, but was critically engaging viewers in the visual and psychological dynamics of 'race' at the turn of the century."[1]

On the surface, Du Bois's albums of portraits do not seem to be more than a series of handsome front and profile studio portraits taken of young African-American men and women. Encoded in them, however, is a narrative created by Du Bois that contradicts the stereotypes and misrepresentations of African-Americans that were common at the beginning of the twentieth century.[2]

As pointed out in detail by Smith, during the late nineteenth century eugenicists such as Francis Galton had used photographs as a means of classifying and defining different racial groups. According to Galton, physical features provided an index of the intellectual and creative potential of different individuals and the racial groups to whom they belonged. Employing a series of standardized formal and profile "mug shots" of individuals from different racial groups,

> Galton imagined his composite photographic records would serve as a kind of key for (presumably whites) viewers, as a map of the radicalized body, allowing one to study abstract, "pure racial characteristics and later to discern the racial identity of individuals according to that model, to assess their corresponding

intellectual attributes and to situate them "appropriately" along a sliding social scale stratified by biological difference.[3]

Galton's work, to a large degree, represented a continuation of earlier phrenological theory. Described as "the only true science of mind," phrenology was based on theories of the Viennese physician Franz Joseph Gall (1758-1828). According to Gall's theory, the brain was the organ of the mind, which has multiple faculties. The size of the brain was an indicator of its potentials, and the shape of the skull a reflection of the brain. By reading the shape of the skull, an accurate index of psychological aptitudes and tendencies could be determined.[4]

Divisions of the organs of phrenology marked externally based on Dr. Spurzheim. Boston: Pendleton's Lithography, c. 1834.

Du Bois's selection of "Portraits of Negroes," as well many of the more general photographs included by him in the Georgia Negro Exhibit, challenges racial sterotypes and the idea that there was a uniform or typical Negro. Du Bois's photographs clearly demonstrate that there is no uniform Negro, but instead a complex diversity that is at work. In the dozens of individual portraits Du Bois included in the Georgia Negro Exhibit it is clear that African-Americans at the turn of the century were racially mixed with White/European Americans—a reality that is essentially denied by the mainstream. What Du Bois points to is a profound and important reality that Blacks were in fact "African-Americans."

Francis Galton, Composite portraits of criminal types included in *Inquiries into Human Faculty and Its Development* (London: Macmillan, 1883).

In doing so, Du Bois demonstrated that race was a dynamic and changing concept, and that African-Americans were a complex mix of both African, European, and other bloodlines. This is a topic that he examines many years later in the first chapter of his book *Black Folk Then and Now*, where he explains that "race would seem to be a dynamic and not a static conception, and the typical races are continually changing and developing, amalgamating and differentiating."[5]

Du Bois's Georgia Negro Portraits clearly demonstrate that there is no "typical" Black person, and that, in fact, American Negroes were not simply African and brown-eyed, but also European and blue-eyed, dark-skinned and light skinned, and so on. This is clearly evident in both the portraits and more general pictures that Du Bois includes in the Georgia Negro Exhibit.

For example, in one of the general portraits included in the Du Bois compilation on Georgia Negroes is the picture of a little girl—perhaps two or three years of age. Dressed in a white linen dress with ruffles and lace, she clearly is fair skinned with blonde curls. Another photograph shows a young girl of perhaps ten years of age thumbing through the pages of an illustrated book. Very fair skinned, she wears a white-lace dress and has shining black hair that is elaborately curled. The child is clearly of racially mixed origin, and defines being Negro as something that is much more complex and multicultural than what the racial stereotypes that were prevalent in the culture suggested.

Other photographs included by Du Bois in the Georgia Negro Exhibit suggest that African-Americans in Georgia represented many different levels in terms of social and economic class. Photographs are included showing well-dressed multi-generational families posing in park like settings, as well as young women wearing

fashionable clothes and businessmen in their offices. Women students on the steps of Atlanta University are included in the Du Bois compilation, along with a young nurse reading a book, the exterior of a local drug store and its prosperous interior, as well as well a young woman being taught to play the piano. These photographs provide examples of Negroes who defy in their portraits the racial stereotypes that were prevalent in the culture. They suggest the idea of social advancement and improvement—quite literally the emergence of Du Bois's "Talented Tenth." In this regard, Du Bois presented a new visual codification of the American identity, one which literally represented a new way of looking at African-Americans.

African-American girl, full-length portrait, seated in chair, head resting on right hand, facing front. Included in Types of American Negroes, compiled and prepared by W. E. B. Du Bois, v. 1, no. 60.

In the following chapter, I have selected some of the most interesting photographs from the Georgia Negro Exhibit. Reproducing all of the images would require a book in and of itself. Nearly all of the images included in this chapter were taken by the Atlanta-based photographer Thomas Askew. Shawn Michelle Smith maintains that his photographs are particularly noteworthy in terms of how they "challenge the 'evidence' of race science by posing counterimages." Likewise, as she explains, they are significant in how "they contest white supremacy" in subtle and important ways (p. 75). In many regards, included in the Georgia Negro Exhibit are the most important photographs included in the Exhibit of American Negroes. Their content, however, requires reflection, since lacking captions, they are only capable of being interpreted in an and of themselves. In fact, this is how

Du Bois presented them at Paris, literally as images which spoke for themseleves. It is exactly in this way that I believe they should be looked at and be understood in the rest of this chapter.

NOTES

1. Shawn Michelle Smith, "Looking at One's Self through the Eyes of Others": W. E. B. Du Bois's Photographs for the 1900 Paris Exposition, *African-American Review*, 2000, Vol: 34, No. 4, p. 581.

2. According to Smith: "Du Bois's 'American Negro' photographs subvert the visual registers and cultural discourses that consolidated white middle-class privilege in opposition to an imagined 'negro criminality' at the turn of the century. Interrogating both middle-class identity and whiteness, Du Bois's images signify across the multivalent boundaries that divide the 'normal' from the 'deviant,' challenging not only the images of African-Americans produced 'through the eyes of others' but also the discursive binaries of privilege that maintain those images. Through a process of visual doubling, Du Bois's 'American Negro' portraits engender a disruptive critical commentary that troubles the visual and discursive foundations of white middle-class dominance by destabilizing their oppositional paradigms" (Ibid.).

3. Shawn Michelle Smith, *American Archives: Gender, Race and Class in Visual Culture* (Princeton, N.J.: Princeton University Press, 1999), pp. 162-163.

4. For background on phrenology as a scientific and social movement see: John D. Davis, *Phrenology: Fad and Science; A 19th-Century American Crusade* (Hamden, C. T.: Archon Books, 1972); and John van Wyhe, *Phrenology and the Origins of Victorian Scientific Naturalism* (Burlington, V. T.: Ashgate, 2003).

5. W. E. B. Du Bois, *Black Folk Then and Now: An Essay in the History and Sociology of the Negro Race* (New York: Henry Holt and Company, 1939).

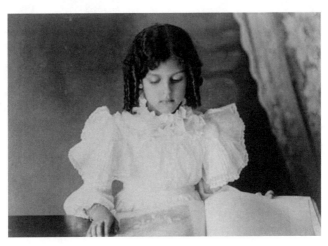

African-American girl, half-length portrait, looking at open book. Types of American Negroes, compiled and prepared by W. E. B. Du Bois, v. 1, no. 77.

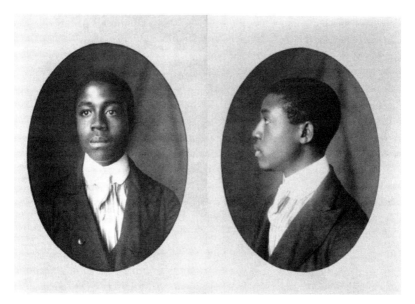

Young African-American man. In album (disbound): Types of American Negroes, compiled and prepared by W. E. B. Du Bois, v. 1, nos. 1 and 2.

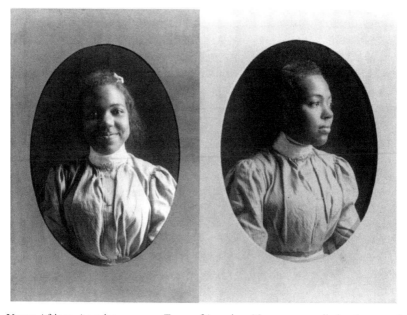

Young African-American woman. Types of American Negroes, compiled and prepared by W. E. B. Du Bois, v. 1, nos. 3 and 4.

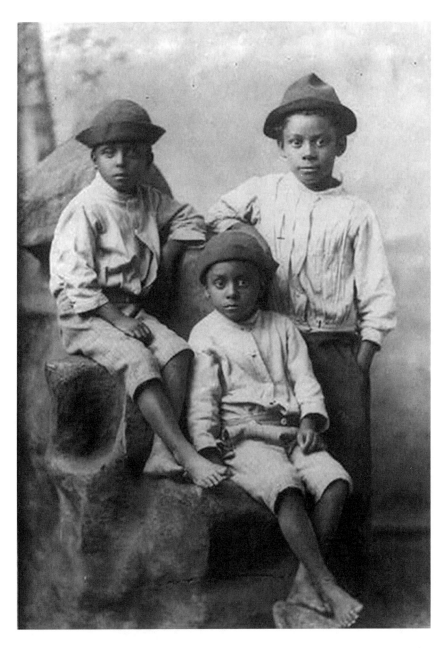

Three African-American boys. Types of American Negroes, compiled and prepared by W. E. B. Du Bois, v. 3, no. 214.

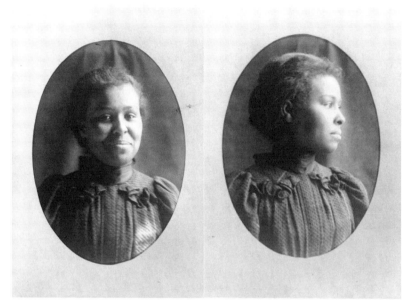

African-American woman, head-and-shoulders portraits. In album (disbound): Types of American Negroes, compiled and prepared by W. E. B. Du Bois, v. 1, nos. 7 and 8.

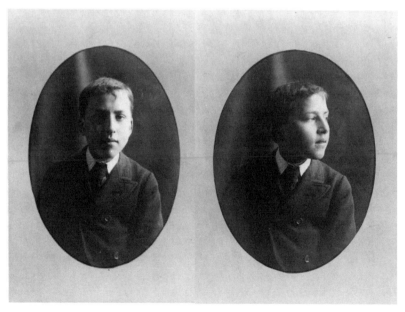

African-American man. In album (disbound): Types of American Negroes, compiled and prepared by W. E. B. Du Bois, v. 1, nos. 17 and 18.

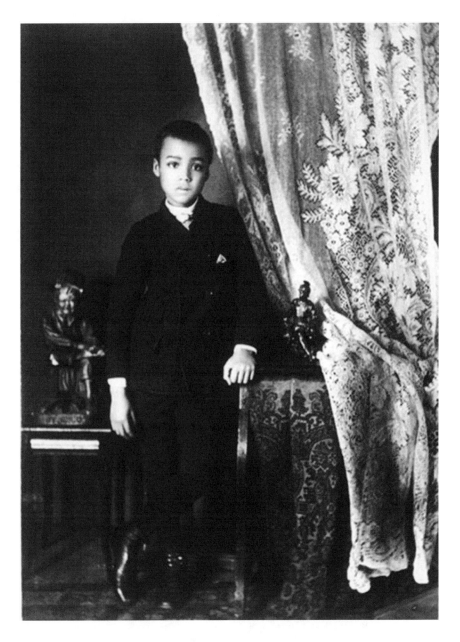

African-American boy, full-length portrait, standing, facing front with left hand resting on table. In album (disbound): Types of American Negroes, compiled and prepared by W. E. B. Du Bois, v. 1, no. 42.

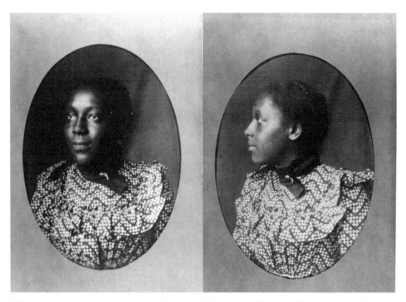

African-American woman. In album (disbound): Types of American Negroes, compiled and prepared by W. E. B. Du Bois, v. 1, nos. 21 and 22.

African-American man. In album (disbound): Types of American Negroes, compiled and prepared by W. E. B. Du Bois, v. 2, nos. 177 and vol. 2 no. 178.

African-American girl, half-length portrait, with right hand to cheek, with illustrated book on table. In album (disbound): Types of American Negroes, compiled and prepared by W. E. B. Du Bois, v. 3, no. 210.

African-American woman. In album (disbound): Types of American Negroes, compiled and prepared by W. E. B. Du Bois, v. 2, nos. 191 and 192.

African-American woman. In album (disbound): Types of American Negroes, compiled and prepared by W. E. B. Du Bois, v. 2, nos. 103 and 104.

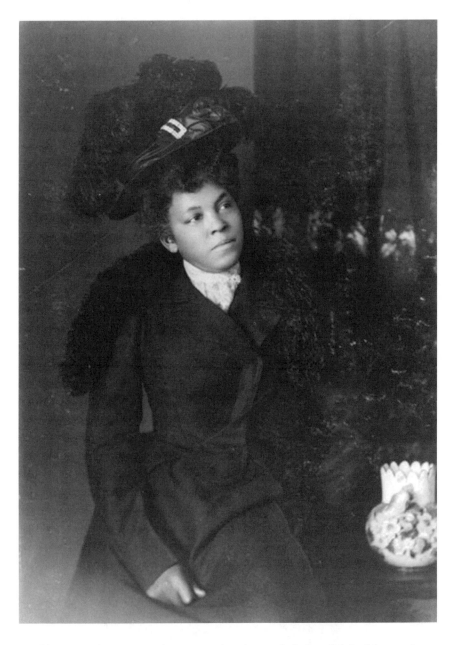

African-American woman, three-quarter length portrait, facing slightly right, wearing hat. In album (disbound): Types of American Negroes, compiled and prepared by W. E. B. Du Bois, v. 1, no. 39.

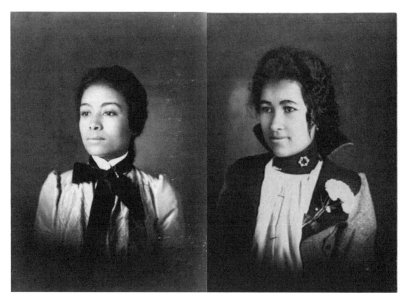

African-American women. In album (disbound): Types of American Negroes, compiled and prepared by W. E. B. Du Bois, v. 1, nos. 86 and 87.

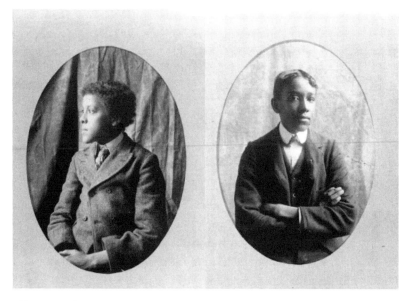

African-American young men. In album (disbound): Types of American Negroes, compiled and prepared by W. E. B. Du Bois, v. 2, nos. 161 and 183.

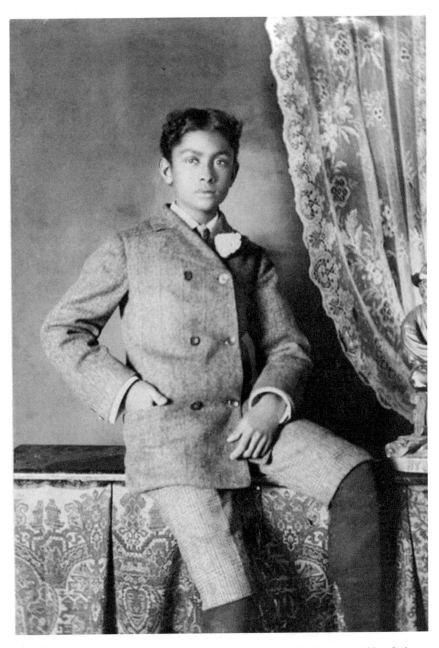

African-American boy, three-quarter-length portrait, half-sitting on table, facing front. In album (disbound): Types of American Negroes, compiled and prepared by W. E. B. Du Bois, v. 3, no. 209.

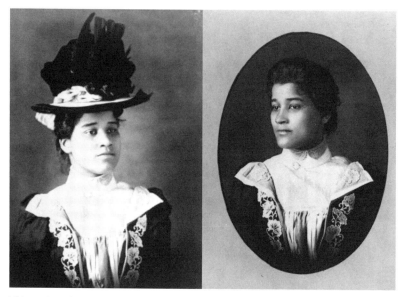

African-American woman. In album (disbound): Types of American Negroes, compiled and prepared by W. E. B. Du Bois, v. 1, nos. 97 and 98.

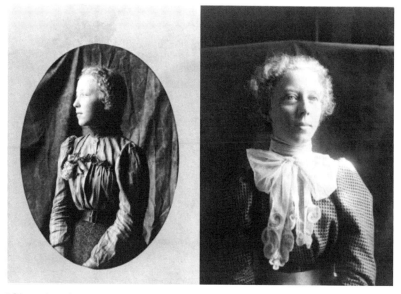

African-American woman. In album (disbound): Types of American Negroes, compiled and prepared by W. E. B. Du Bois, v. 1, no. 35 and vol. 2, no. 143.

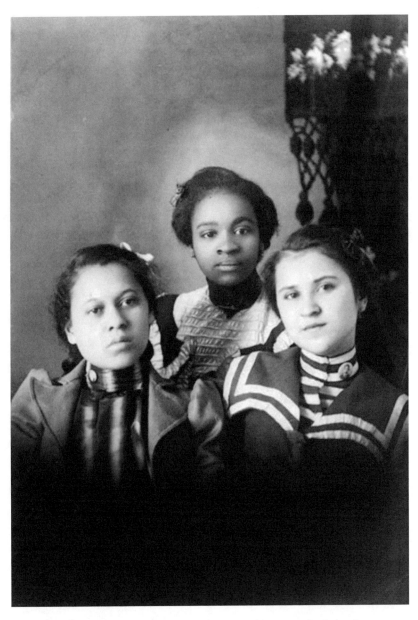

Three African-American girls, head-and-shoulders portrait, facing front.
In album (disbound): Types of American Negroes, compiled and prepared by
W. E. B. Du Bois, v. 1, no. 41.

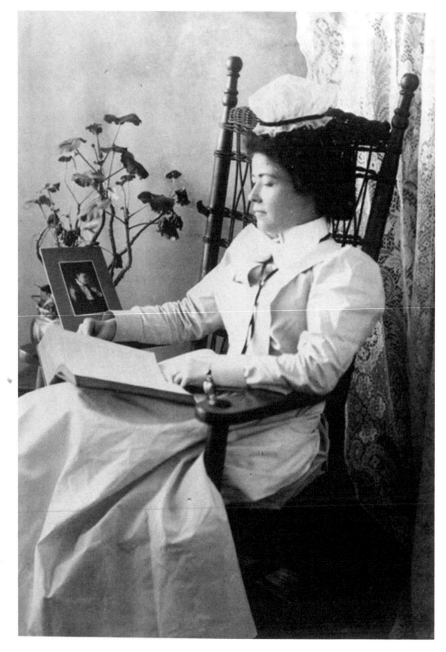

Nursing student wearing a starched white uniform, seated in a rocking chair, reading. In album (disbound): Types of American Negroes, compiled and prepared by W. E. B. Du Bois, v. 3, no 219.

PRELIMINARY LIST

OF

BOOKS AND PAMPHLETS BY NEGRO AUTHORS

FOR

PARIS EXPOSITION AND LIBRARY OF CONGRESS.

COMPILED BY

DANIEL MURRAY, LIBRARY OF CONGRESS,

WASHINGTON, D. C.

FOR THE AMERICAN NEGRO EXHIBIT,
PARIS EXHIBITION OF 1900,
THOS. J. CALLOWAY, Special Agent.

Cover from Daniel Murray's *Preliminary List of Books and Pamphlets by Negro Authors*.

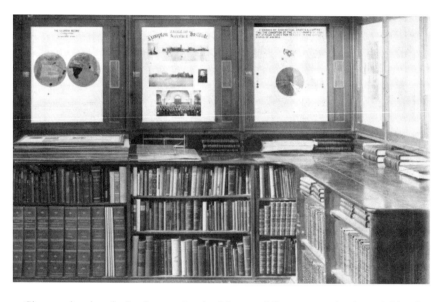

Closeup showing the books sent by the Library of Congress to the the Exhibit of American Negroes at the Paris 1900 Exposition.

Books and Pamphlets by Negro Authors

The Exhibit of American Negroes was not only remarkable in terms of the sociological and visual material it collected, but also the information it contained about black writers. Under the direction of Daniel A. P. Murray (1852-1925), who worked at the Library of Congress from 1871-1923, a bibliography of black authors was created for the exhibit. Hundreds of books and pamphlets were assembled from the bibliography and sent to Paris. Many of the pamphlets sent to the Paris Exposition are now available as part of the American Memory Project at the Library of Congress. Large numbers of the books sent to Paris from the Library of Congress reside in the Moorland-Spingarn Collection at Howard University. At the time of this publication, they are not being made available to researchers. The list of books included below is taken directly from Murray's publication for the Paris 1900 Exposition. It represents perhaps the most interesting bibliography of its type that deals with African-American culture and life in the years prior to the beginning of the twentieth century.

Allen, Richard, *Autobiography*. Philadelphia, 1888.

Allen, Richard, *Autobiography*. Philadelphia, 1793.

Anderson, Matthew, *Presbyterianism*.

Anderson, William, *Appointed*.

Anonymous, *Narrative of Joanna*. 1838.

Armstrong, J. H., *What Communion Hath Light with Darkness*. Philadelphia, 1894.

Arnett, Benj. W., *Life of Paul Quinn*.

Arnett, Benj. W., *Speeches and Addresses of Negroes, collected and published*. 15 vols.

Arnett, Benj. W., *Orations and Speeches*, J. M. Ashley.

Ayler, J. C., *Guide Lights*. Princeton, 1887.

Bailey, Ida D., *Atlanta Souvenir Cook Book*. Washington, D.C.

Beadle, Saml. Alfred, *Sketches from Life in Dixie*.

Benjamin, R. C. O., *The Boy Doctor*.

Benjamin, R. C. O., *History of British West Indies*.

Benjamin, R. C. O., *Future of the American Negro*.

Benjamin, R. C. O., *The Southland*.

Benjamin, R. C. O., *Africa, the Hope of the Negro*.

Benjamin, R. C. O., *Life of Toussaint L'Overture*.

Benjamin, R. C. O., *Poems*.

Benjamin, R. C. O., *Historical Chart of Colored Race.*

Bias, J. J. Gould, *Synopsis of Phrenology.*

Bell, J. Madison, *Poems.* Philadelphia.

Bibb, Eloise, *Poems.* Boston, 1895.

Binga, A., *Sermons.* Richmond, 1889.

Black, Andrew, *Two Roads.* Sumpter, S.C.

Blackwell, G. L., *Model Homestead.*

Blyden, Edward, *Liberia's Offering.* London, 1862.

Blyden, Edward, *Christianity, Islam and the Negro.*

Blyden, Edward, *From West Africa to Palestine.*

Booth, C. O., *Plain Theology for Plain People.*

Bowen, J. W. E., *Africa and the American Negro.*

Brent, Linda, *Incidents in the Life of a Slave Girl.*

Brooks, Chas. H., *History of the Grand United Order of Odd Fellows.* Philadelphia, 1893.

Brown, Margaret, *French Cook Book.* Washington, D.C., 1886.

Brown, William Wells, *The Black Man.* New York, 1863.

Brown, William Wells, *The Negro in the Rebellion.* Boston, 1867.

Brown, William Wells, *Clotelle.* Boston, 1867.

Brown, William Wells, *The Rising Son.* Philadelphia, 1874.

Brown, William Wells, *Three Years in Europe.* London, 1852.

Bruce, H. C., *The New Man.*

Campbell, Jabez P., *Echoes from the Cabin*, etc.

Campbell, R., *My Mother Land.*

Cannon, N. C. W., *Rock of Wisdom.*

Carson, Hannah, *Glory in Affliction.* Philadelphia, 1864.

Caruthers, *Poems.*

Chesnut, Chas. W., *The Conjure Woman.*

Chesnut, Chas. W., *Life of Frederick Douglass.*

Chesnut, Chas. W., *Wife of His Youth*, etc.

Clark, Peter H., *History of the Black Brigade.*

Coleman, L. H. N., *Poor Ben.* Philadelphia, 1889.

Coleman, W. H., *A Casket of Pulpit Thought.* 1889.

Coleman, N. and Coffin, A. O., *Native Plants of Marshall, Texas.*

Coker, Benjamin, *Anti-Slavery Pamphlet.* Baltimore, 1820.

Coker, Daniel, *Anti-Slavery Pamphlet.* 1810.

Cooper, Mrs. A. J., *A Voice from the South.* Xenia, 1892.

Coppin, Levi J., *Key to Scriptural Interpretation.*

Coppin, Levi J., *Relation of Baptized Children to the Church.* Nashville, 1890.

Coston, W. H., *A Freeman Yet a Slave.*

Councill, W. H., *Lamp of Wisdom.*

Crogman, W. H., *Talks for the Times*.

Crogman, W. H., *Progress of a Race*.

Cromwell, John W., *History of Bethel Historical and Literary Association*. 1895.

Crosthwait, Wm. A., *The Negro Problem*.

Crummell, Alex., *The Greatness of Christ*. 1871.

Crummell, Alex., *Africa and America*. 1861.

Crummell, Alex., *Future of Africa*.

Crummell, Alex., *Civilization the Primal Need*, etc. 1898.

Cugoano, Ottobah, *Narrative of Enslavement*. 1787.

Davis, D. Webster, *Poems*.

Delaney, Martin R., *Principles of Ethnology*. 1879.

Delaney, Martin R., *Condition of the Colored People*. 1852.

Delaney, Martin R., *Life—*

Douglass, Fred., *Life and Times*, etc.

Douglass, Fred., *My Bondage and My Freedom*.

Douglass, Fred., *Haiti*.

Douglass, Fred., *Lynchings in the South*.

Douglass, Wm., *Annals of the First African Church*. Philadelphia, 1862.

Dube, John L., *A Talk on My Native Land*. 1892.

Du Bois, Wm. E. B., *Suppression of the Slave Trade*, etc.

Du Bois, Wm. E. B., *Philadelphia Negro*.

Dunbar, Paul L., *Oak and Ivy*.

Dunbar, Paul L., *Majors and Minors*.

Dunbar, Paul L., *Lyrics of Lowly Life*.

Dunbar, Paul L., *Uncalled*.

Dunbar, Paul L., *Folks from Dixie*.

Dunbar, Paul L., *The Hearthside*.

Dunbar, Paul L., *Poems of Cabin and Field*.

Durham, John S., *How to Teach History*.

Dyson, J. F., *Richard Allen's Place in History*.

Dyson, J. F., *Unity of Human Race*, etc.

Earle, Victoria, (Mrs. Matthews), *Aunt Lindy*. 1893.

Easton, William E., *Dessalines*.

Embry, J. C., *Digest of Christian Theology*.

Embry, J. C., *Our Father's House*.

Equiano, O., *Autobiography*. Boston, 1837.

Flipper, H. O., *Colored Cadet at West Point*.

Fortune, T. T., *Negro in Politics*.

Fortune, T. T., *Black and White*.

Foote, Julia A., *Brand Plucked from Fire*.

Fredric, Frances, *Fredric's Slave Life.*

Gaines, W. J., *African Methodist in the South.*

Gaines, W. J., *The Negro and the White Man.*

Gaines, D. B., *Racial Possibilities.*

Garnet, Henry Highland, *Pamphlet Addresses.*

Garnet, H. H., *Garnet's Memorial Discourse.* 1865.

Grant, A., *The Literary and Historical Society, Georgia Conference.*

Green, A. R., *Life of Rev. D. F. Davis.*

Gregory, J. M., *Frederick Douglass, the Orator.*

Gresham, G. N., *Mathematics,* (textbook).

Griggs, S. E., *Imperium in Imperio.*

Grimke, A. H., *Life of Charles Sumner.*

Grimke, A. H., *William Lloyd Garrison.*

Hagood, L. M., *Colored Man in the M. E. Church.*

Haley, James T., *Sparkling Gems* (poems).

Holsey, L. H., *Manual of Discipline.*

Hamilton, F. W., *Conversations on the C. M. E. Church.*

Hamilton, F. W., *Plain Account of C. M. E. Church.*

Harper, F. E. W., *Iola Leroy.* 1892.

Harper, F. E. W., *Poems.*

Hayne, Jos. E., *The Black Man.*

Hayne, Jos. E., *Negro in Sacred History.*

Heard, Josie, *Morning Glories.* 1890.

Henson, Josiah, *Father Henson's Story.*

Hood, J. W., *One Hundred Years*, etc.

Hood, J. W., *History of A. M. E. Z. Church.*

Hood, J. W., *Negro in Christian Pulpit.*

Hood, J. W., *Two Characters, Two Destinies.*

Howard, Jas. H., *Bond and Free.* 1886.

Jasper, John, *Sun Do Move.*

Jennings, Paul, *Colored Man's Life of Madison.*

Johnson, E. A. (Mrs.), *The Hazeley Family.*

Johnson, E. A. (Mrs.), *Clarence and Corinne.*

Johnson, Edward A., *School History of Negro Race.*

Johnson, Edward A., *Negro in Spanish-American War.*

Johnson, Jas. H. A., *The Pine Tree Mission.*

Johnston, H. T., *The Divine Logos.*

Johnson, Wm., *Prominent Colored Men of Kentucky.*

Keckley, Mrs. E., *Behind the Scenes.*

Lampton, E. W., *Sacred Dynamite on Baptism.*

Laney, Lucy C., *Struggles for Freedom*. 1890.

Langston, John M., *Freedom and Citizenship*.

Langston, John M., *From the Plantation to the Capitol*.

Leary, John S., *Croatans of North Carolina*.

Lewis, R. B., *Light and Truth*. Boston, 1858.

Loguen, J. W., *As a Slave and as a Freeman*.

Love, E. K., *History of the First African Baptist Church*.

Lynk, M. W., *Afro-American Speaker*.

McClellan, G. M., *Poems*.

Magee, J. H., *The Night of Affliction*.

Majors, M. A., *Noted Negro Women*.

Menard, J. Willis, *Lays from Summer Lands*.

Mixon, M. H., *A Methodist Luminary*.

Mixon, M. H., *Moth of Ignorance Must Be Destroyed*.

Moore, Alice Ruth (Mrs. Dunbar), *Violets*.

Moore, Alice Ruth (Mrs. Dunbar), *Goodness of St. Roque*.

Moore, J. J., *History of A. M. E. Z. Church*. 1884.

Mossell, Mrs. N. F., *Work of Afro-American Women*.

Mossell, C. W., *Toussaint L'Overture*.

Myrick, D. J., *Scripture Baptism*. 1882.

Nell, W. C., *Colored Patriots of the Revolution*. 1855.

Anonymous, *The Negro Pew. Boston*, 1837.

Newsom, J. T. C., *Know What You Want to Say*, etc.

Northrop, Solomon, *Twelve Years a Slave*.

Ousley, Benj., *Translation of Gospels and Acts*.

Paige, T. F., *Twenty-Two Years of Freedom*.

Payne, Daniel A., *Recollections of Seventy Years*.

Payne, Daniel A., *Treatise on Domestic Education*.

Payne, Daniel A., *History of A. M. E. Church*. 1891.

Payne, Daniel A., *Pleasures, and Other Miscellaneous Poems*. Baltimore, 1850.

Paynter, John H., *Joining the Navy*.

Penn, I. Garland, *Afro-American Press*. 1891.

Penn, I. Garland, *The Educator*.

Pennington, Jas. W. C., *Pamphlets, Addresses*.

Perry, Rufus L., *The Cushite*. 1893.

Phillips, C. H., *History Colored M. E. Church*.

Pope, Barbara, *Storiettes*.

Proctor, H. H., *The Negro and the War*.

Quadroon (anon.), *A Colored Man around the World*.

Randolph, E. A., *Life of Rev. John Jasper*. Richmond, 1884.

Randolph, Peter, *Sketches of Slave Life*. 1855.

Ransome, R. C., *School Days at Wilberforce*. 1892.

Ray, H. Cordelia, *Lincoln* (A Poem). 1893.

Ray, H. Cordelia, *Sonnets*. 1893.

Rector, John K., *Chart of Negro Progress*. 1898.

Rideout, Jr., D. A., *Life of D. A. Rideout, Sr.* 1891.

Riley, Jerome F., *Philosophy of Negro Suffrage*.

Rowe, Geo. C., *Thoughts in Verse*. 1887.

Rudd, L. E., *Catholic Afro-American Congresses*. 1893.

Rush, Christopher, *Rise and Progress of the A. M. E. Z. Church*. 1892.

Sampson, John P., *Temperament and Phrenology of Negro Race*.

Sampson, John P., *Mixed Races*. 1881.

Scarborough, W. S., *First Greek Lessons*. 1881.

Scarborough, W. S., *The Birds of Aristophanes*.

Scruggs, L. A., *Women of Distinction*.

Shorter, S. L., *Heroines of African Methodism*.

Seaton, D. P., *The Land of Promise*.

Sevelli, Capponi, *Ham and Dixie*.

Shadd, Mary Ann, *Condition of Colored People*. Wilmington, Del., 1849.

Simmons, W. J., *Men of Mark*. 1887.

Smith, Mrs. Amanda, *Autobiography*. 1898.

Smith, C. S., *Liberia in the Light of Living Testimony*.

Smith, C. S., *Monogram of Bishop D. A. Payne*.

Smith, C. S., *Sermons of Bishop D. A. Payne*.

Smith, C. S., *Glimpses of Africa*. 1895.

Smith, Jas. McCune, *Influence of Climate on Longevity*. 1846.

Smith, J. W., *Sermons of Bishop S. T. Jones*.

Smith, L. H., *Earnest Pleas*.

Stallings, W., *The African Triumph*. 1892.

Stevenson, J. W., *Church Financiering*. 1896.

Steward, T. G., *Genesis Re-Read*. 1885.

Steward, T. G., *Life of Mrs. Rebecca Steward*. 1877.

Steward, T. G., *Gospel among U.S. Soldiers*. 1899.

Stewart, Austin, *Life of Solomon Northrop*.

Stewart, Austin, *Twenty-Two Years a Slave, Forty Years a Freeman*.

Stewart, T. McC., *Liberia, the Americo-African Republic*.

Still, William, *The Underground Railroad*.

Straker, D. Augustus, *New South Investigated*. 1888.

Straker, D. Augustus, *Treatise on Larceny of Dogs*.

Tanner, Benj. T., *Theological Lectures*.

Tanner, Benj. T., *Outlines and Government A. M. E. Church.*

Tanner, Benj. T., *Apology for African Methodism.*

Tanner, Benj. T., *Dispensation in the History of the Church.*

Tanner, Benj. T., *The Negro's Origin.*

Talley, Thos. W., *A Natural Trinity.*

Taylor, J. T., *The Negro.* Atlanta, Ga.

Taylor, Marshall W., *Plantation Melodies.* 1883.

Taylor, Marshall W., *Universal Reign of Jesus.*

Taylor, Marshall W., *Life of Downey.*

Taylor, Marshall W., *Negro Evangelist.*

Taylor, Marshall W., *Life of Mrs. Amanda Smith.*

Thomas, I. L., *Colored Man's Reply to Bishop Foster.*

Thorton, M. W., *The White Negro.* 1894.

Trotter, James M., *Music and Some Highly Musical People.*

Truth, Sojourner, *Sojourner Truth's Narrative.*

Turner, Bishop, H. M., *Methodist Polity.* Philadelphia, 1885.

Turner, Bishop, H. M., *The Negro in All Ages.*

Turner, Bishop, H. M., *Printed Speeches and Letters.*

Turner, Bishop, H. M., *Catechism of the A. M. E. Church.*

Turner, Bishop, H. M., *Hymn Book for A. M. E. Church.*

Turner, H. H., *History of Good Samaritans*, etc. 1881.

Vashon, Geo. B., *Pamphlets, Lectures*, etc.

Walker, David, *Walker's Appeal.*

Wallace, John, *Carpet-Bag Rule in Florida.* 1888.

Ward, S. R., *Autobiography of a Fugitive Negro.* London, 1855.

Ward, Saml. Ringgold, *Occasional Papers.*

Washington, B. T., *Black-Belt Diamonds.*

Washington, B. T., *Future of the American Negro.*

Washington, B. T., *Address at Opening Atlanta Exposition.*

Wayman, Alex. W., *Cyclopedia of Methodism.*

Wayman, Alex. W., *Life of Bishop Jas. A. Shorter.*

Wayman, Alex. W., *My Recollections.*

Wheatley, Phillis, *Poems.* London, 1773.

Whitfield, Jas. M., *Poems.* Buffalo, 1853.

Whitman, A. A., *A Man and Yet Not a Man.* 1877.

Whitman, A. A., *Twasinta's Seminoles.* 1890.

Wilkes, L. E., *Life of Frederick Douglass.*

Williams, D. B., *Freedom and Progress.* 1890.

Williams, D. B., *Science and Art of Teaching.* 1880.

Williams, Edward, *John Brown* (Poem). 1889.

Williams, Geo. W., *History of Negro Race*. 1882.

Williams, Geo. W., *History of Negro Troops in Rebellion*. 1888.

Williams, Geo. W., *Negro as a Political Factor*.

Wilson, C. B., *History of G. U. O. of Odd Fellows*.

Wilson, Jos. T., *Black Phalanx*.

Wilson, Jos. T., *Emancipation*. 1882.

Anonymous, "Joshua."

Anonymous, "Fifty Years."

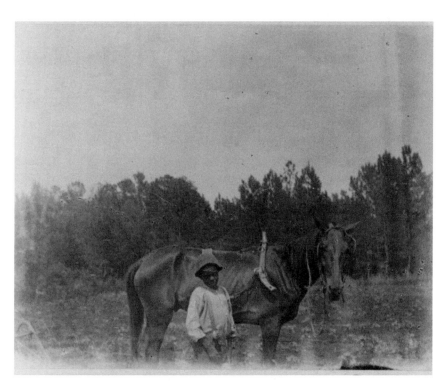

African-American boy standing with horse attached to plow. In album (disbound): Negro Life in Georgia, U.S.A., compiled and prepared by W. E. B. Du Bois, v. 3, no. 241.

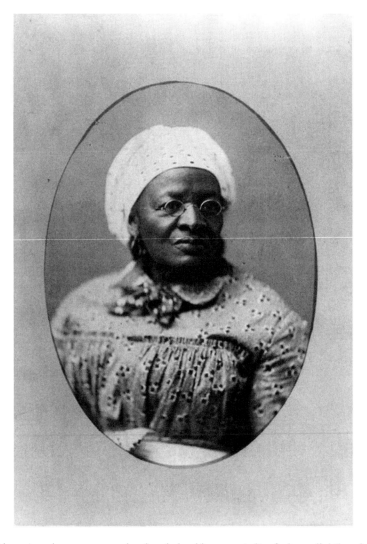

African-American woman, head-and-shoulders portrait, facing slightly right.
In album (disbound): Negro Life in Georgia, U.S.A., compiled and prepared by
W. E. B. Du Bois, v. 1, no. 83.

Compilation of Laws Affecting Blacks in Georgia (Slave and Black Codes) from the Colonial Period to 1900

The Black Codes have their origins in the Slave Codes that were first established during the Colonial period. The Codes or laws were primarily concerned with protecting the economic interests of slaveholders and preventing slaves from running away or rebelling. The most famous slave codes passed into law in the United States prior to Emancipation were the restrictions placed on slaves not being allowed to learn how to read in the years after the Nat Turner Rebellion in 1831.

Every slave state had its own slave code and body of court decisions supporting its code. Slaves were considered property. As property they could not own property or participate in a contract. As a result, slaves could not marry, since marriage represented a legal contract or agreement. Free blacks were subject to various regulations and controls under the Slave Codes despite the fact that they were free.

The Black Codes were passed throughout the Southern states immediately after the Civil War. They clearly have their origins in the Slave Codes. According to Du Bois:

> The original codes favored by Southern legislatures were an astonishing affront to emancipation and dealt with vagrancy, apprenticeship, labor contracts, migration, civil and legal rights. In all cases, there was plain and indisputable attempt on the part of the Southern states to make Negroes slaves in everything but name.

In his 1896 doctoral dissertation and book *The Suppression of the African Slave Trade*, Du Bois included a series of appendices describing legislation affecting African-Americans and the Slave Trade. The references and documents Du Bois collected represent a pioneering model of historical/legal research, which he repeated again in his compilation of laws affecting Blacks in Georgia from the Colonial period to 1900 that he included in the Georgia Negro Exhibit.

Handwritten and totaling approximately four hundred pages in length, Du Bois's compilation of the Black Code in Georgia provides immediate evidence of how the law was systematically used to deprive African-Americans of their legal rights both before and after the Civil War. Included below are selected sections

of the transcriptions copied down by Du Bois and his students that were included in the Georgia Negro Exhibit. The complete compilation can be consulted on microfilm copies available through the Library of Congress.

October 26, 1749

Among the latter were enactments that a penalty of £ 10 should be paid by every master who either forced or permitted his negro slave to work on the Lords day, and if the owner omitted to compel his slave to attend at some time on Sunday for instruction in the Christian Religion, he should be deemed guilty of a misdemeanor, and on conviction, should be fined not less than £5 for each offense.

October 26, 1749

As the culture of silk is the great object of the Trustees, and they are determined to make it as far as is in their power the object of all the people in Georgia by never satisfying any grants in which the proper number of Mulberry Trees, that is the conditions for planting, fencing and keeping, are not inserted and by insisting on the forfeiture of all grants where those conditions are not performed, they have resolved that every man who shall have four male Negroes, shall be obliged to have for every such four, one female Negro instructed in the art of winding silk. The conditions, as mentioned in my other letter are that 10,000 Mulberry Trees shall be planted on every hundred acres, the same proportion to be observed in less grants, and that for the preservation of the Trees against cattle the planter shall fence in the Mulberry Trees or plant them in places already fenced.

As there are several public works which are absolutely necessary, such as maintaining the Lighthouse, providing for the Pilot and Pilot Boat, the repairs of the Church, the wharf, the prison, and building Sagarettos and other public services such as the support of the Minister when other supports shall fail, and several officers of Civil Government, as Constables Tything men to and as some funds will be requisite for these, the Trustees, think nothing can be more reasonable that a duty upon Negroes at importation, and an annual tax per head upon the possession of them, which tax and duty much be paid for the use of the Trust into the hands of proper persons appointed by the Trustees. It will therefore be requisite for you in your consultation to consider what duty and tax may in

your opinion be proper for the aforesaid services, and other necessary public uses of Colony, and transmit your opinion hereon under the seal as before, by the first opportunity.

I am, Sir and Gentlemen,
Your very humble servant,
Benjamin Martyn, Sec.

To William Stephens, Esq. Pres. And the Assistants
By the Charles-Town Galley – Capt Bogg

A convention was called in due course, and Mayor Horton, the military chief of the colony, prescribed over its deliberations. A conclusion was speedily reached. The suggestions of the trustees were substantially adapted; and on the 26th of Oct. 1749, a representation was signed by twenty-seven persons of the highest respectability in the province, requesting that slavery be at once allowed under the limitations mentioned. The doctrinent, properly attested, was forwarded by the earliest opportunity to the trustees who, with a few trifling modifications and additions approved its provisions.

October 26, 1749

No Articifer shall be suffered to take any Negro as an Apprentice nor shall any Planter lend or let out a negro or Negroes to another Planter to be employed otherwise than in manuring and cultivating the plantations.

Proprietors of Negroes shall not be permitted to exercise an unlimited power over them.

All Negroes imported into or born in the Province of Ga., shall be registered, and no sale of Negroes from one man to another shall be valid unless registered. Inquisitions shall be made once in every year, and oftener if need be into the Registers by Juries of the several Districts, who shall immediately afterwards make the report to the Magistrates.

As other Provinces have greatly suffered by permitting ships with Negroes to send them on shore when all of contagious distempers (as particularly South Carolina has often by the Yellow Fever) proper places must be appointed for such ships as bring Negroes to Georgia to cast anchor at in order to their being visited and to perform such Quarantines as shall be ordered by the President and Assistants and no ships must be suffered to come nearer than those places before

they are visited by proper officers and a certificate of Health is obtained. And in case of any contagious distempers on board, proper places must be appointed at a distance from the town for Sagrettos where the whole crew of ships and the Negroes my be lodged and supplied with refreshments and assisted towards their recovery. You must acquaint the Trustees by the first opportunity with the names and descriptions of the proper places for the ships to stop at, and likewise where to perform a Quarantine if there are contagious distempers on board, that those places may be specified in the act.

No master shall oblige or even suffer his Negro or Negroes to work on the Lords Day, but he shall permit or oblige them to attend at some time in that Day for instruction in the Christian Religion which the Protestant Ministers of the gospel must be obliged to give them. The Minister or Ministers shall on all occasion inculcate in the Negroes the natural obligations to a married state where there are female slaves cohabiting with them and an absolute forbearance of blaspheming the name of God by profane cursing or swearing. No intermarriage between white people and negroes shall be deemed lawful marriages and if any white man shall be convicted of lying with a female negro he or she shall on such conviction be… and the negro shall receive a corporal punishment.

November 17, 1765

An Act to amend an act, regulating patrols, passed the 18th November, 1765, so as to vest the appointment of patrols in the justices of the peace.

Approved December 20, 1830.

Sec. I. From and after the passage of this act, the justice or justices of the peace in each captain's district in this State shall be, and they are hereby authorized and required to appoint patrols for their respective districts, make out a schedule of all persons liable to do patrol duty, and at the first justice court in their district or in five days thereafter, they shall organize patrol companies as the law directs and exercise all the powers in doing so, and enforcing the same, that are vested in the captains or other militia officers, for neglect of duty, to be subject to like penalties or forfeitures.

December 24, 1768

An act to amend and continue an act for the establishing and regulating patrols, and for preventing any person from purchasing provisions or any other commodities from, for selling suchs to any slave unless such slave shall produce a ticket from his or her owner, manager, or employer.

Sec I. Whereas, the seventh and ninth clauses of the "Act for the establishing and regulating patrols, and for preventing any person from purchasing provisions or any other commodities from, or selling such to any slave, unless such slave shall produce a ticket from his, or her owner, manager or employer" do refer to the act of the General Assembly of this province entitled "An act for the better governing of negroes and other slaves in this province, and to prevent the inweighing or carrying away slaves from their masters or employers" of which act his majesty hath declared his royal disallowances and the several directions therein contained and to which the said first recited act doth refer, are thereby annulled and of non effect, by which means many inconveniences have arisen, to remedy which, Be it enacted. That unless in the presence of some white person, to carry and make use of fire arms, or any offensive weapon whatsoever, unless such slave shall have a ticket or license in writing from his master, mistress or overseer, to hunt and kill game, cattle or mischievous birds, or beasts of prey, and that such license be remembered and renewed once every week, or unless there be some white person of the age of fifteen years or upwards in the company of such slave, when he is hunting or shooting, or that slave be actually carrying his master's arms to, or from his master's plantation by a special ticket for that purpose or unless such slave be found in the day time actually keeping off birds within the plantation to which such slave belongs, lodging the same gun at night within the dwelling house of his master or white mistress or overseer, Provided always. That no slave shall have liberty to carry any gun, cutlass, pistols or other offensive weapon abroad at any time between Saturday evening after sunset, and Monday morning before sunrise notwithstanding a license or ticket for so doing.

Sec. II. And be it further enacted, That in case any or either of patrols established, or to be established within this province, by virtue of the said act on searching and examining any negro house for offensive weapons, fire arms and ammunition, shall find any such or in case any person shall find any slave using or carrying fire arms or other offensive weapons contrary to the intent and meaning of this act, such patrol or person or persons may lawfully seize and take such offensive weapon, fire arms and ammunition, but before the property thereof shall be vested in the person or persons who.

May 10, 1770

An Act to amend the twenty section of An Act for ordering and governing Slaves within this Province, and for establishing a jurisdiction for the trial of offences committed by such slaves other person therein mentioned, and to prevent the inweighing and carrying slaves from their masters, owners or employers, passed 10th of May 1770.

Approved December 26, 1835.

Whereas the twenty-ninth section of said act does not make it penal with free persons of color to harbor, conceal or entertain any slave, who may be a runaway, but merely inflicts a fine on such free persons of color: for a remedy whereof –

Sec. I. Be it enacted, That from and after the passage of this act, all free persons of color within this State, who shall harbor, conceal or entertain a slave or slaves, who shall be charged or accused of any criminal matter, or shall be a runaway, shall, upon conviction, in addition to the penalty already provided for in said section, be subject to the same punishment as slaves are under said section of the above recited act.

Sec. II. Any lawful constable having reason to suspect that runaway slaves, such negroes who may be charged or accused of any criminal offence, are harbored, concealed or entertained in the house or houses of such slaves or free persons of color, they or any of them are authorized to enter such house or houses, and make search for the said runaway or runaways, or accused criminal or criminals.

May 10, 1770

An Act to alter and amend an Act for the ordering and governing of Slaves within this State, passed the 10th of May, 1770.

Sec. I. Be it enacted by the Senate and House of Representatives of the State of Georgia, in General Assembly met, and it is hereby enacted by the authority of the same, That the forty third section of the said act, passed the 10th of May 1770, for the ordering and governing of slaves within this State, be, and the same is hereby repealed.

Sec. II. And be it further enacted, That from and after the passage of this act, every owner or owners who may keep on any plantation the number of ten slaves or more, over the age of sixteen, shall be compelled to keep a white man capable

of bearing arms, as an overseer, manager or superintendent, on said plantation, under the penalty, contained in the said forty third section so repealed.

David Adams,
Speaker of the House of Representatives.
Thomas Stocks
President of the Senate
Assented to December 20, 1823

December 19, 1793

An act to prevent the importation of negroes into this state from the places herein mentioned.

Sec. I. Prohibits the importation of negroes reenacted by the constitution.

Sec. II. And be it further enacted, That all free negroes, mulattoes, mestizoes, who at any time after the passing of this act shall continue into this state, shall, within thirty days of their arrival, enroll him, her or themselves in the clerk's office of the county wherein they reside; and within six months thereafter procure a certificate of two or more magistrates of the county certified by the clerk thereof with the seal of the county annexed of his, her or their honesty and industry, to entitle them to the privileges of residence in this state; and in failure of such enrollment, or neglect of procuring such a certificate, he, she or they, shall be subject to be taken up and committed to the nearest jail, for a term not exceeding three months, or until he, she or they, shall give security, by two freeholders, for his, her or their prison fees, and future industrious and honest behavior.

Sec. III. And be it further enacted, That from and after the passing of this act, the state shall in no instance be answerable for or liable to pay the owners any consideration whatever for any negro slave or slaves who may suffer death by the laws of this state.

Sec. IV. And be it further enacted by the authority aforesaid, That all expenses and fees, chargeable by any of the public officers, for prosecuting any slaves convicted of any crime not capital against the laws of this state, shall be paid by the owner or owners of such slave or slaves. But in all cases where any slave shall be convicted of any crime whereby he, she or they, may suffer death, the expenses attending the trial and execution of such slave or slaves, shall be paid by the county where such slave or slaves, shall be executed.

Williams Gibbons,
Speaker of the House of Representatives.
Benjamin Taliaferro,
President of the Senate.
December 19, 1793.
George Matthews, Governor.

December 10, 1803

An act to amend the act of 1770.
Approved Dec. 10, 1803.

Section I. Prohibits trading with slaves. Re-enacted.

Section II. If the owner or owners of any slave, shall permit such slave for a consideration or otherwise to have, hold and enjoy the privilege of laboring, or otherwise transacting business for his, her, or themselves, except on their own premises, such owner or owners shall, for every such weekly offence, forfeit and pay the sum of $30.00 except in the cities of Savannah and Augusta, and the town of Sunbury.

Section III. The several fines and penalties imposed in pursuance of this act, or the before-recited act, shall in no one instance exceed the sum of $30.00 and shall be recovered before a justice of the peace, in the usual form liquidated demands, a minority thereof shall, within thirty days thereafter, be transmitted by justice of the peace, before whom the same shall be recovered, to the clerk of the inferior court of the county where he resides, in support of the funds thereof.

Section IV. Nothing herein contained shall go to compel any slave to be put on his trial twice for one and the same offence.

Prince's Digest
Slaves, Patrols, and Free Persons of Color.
Approved December 10, 1803.

December 8, 1806

An act to amend the 2d and 4th sections of the act of 1765. [For the title see Section 1.]

Approved Dec. 8, 1806.

Section I. Whereas the fines imposed by said act for the refusal and neglect of patrol duty is found from experience to be inadequate to the purpose therein intended – for remedy whereof,

Be it enacted, That any person liable to do and perform patrol duty as prescribed in the above recited act, who shall refuse or neglect to do and perform the same, shall forfeit and pay a sum not exceeding $5.00 for each offence, to be adjudged by a majority of the militia officers of the company district where the offence shall be committed, and levied by the distress and sale of the offender's goods, under the hand and seal of the captain or commanding officer of such company, to be paid over to the inferior court, for the use of the poor of the county where such offence shall be committed; unless suffcient excuse be made to the officers of such company on their next ensuing muster day. And it shall be the duty of the commanders of patrols to make a just, true return of all defaults in respective districts to the captain or commanding of the company, on the muster day after they shall have been appointed. And if any person, shall have been regularly appointed to command the patrol, agreeable to the above-recited act, who shall refuse to accept of such command, or after acceptance thereof, shall refuse or neglect to do his duty, such person so offending shall, for every such offence, forfeit and pay a sum not exceeding $10.00, to be adjudged by a majority of the officers of the company, and levied by distress and sale of the offenders goods, under the hand and seal of the captain or commanding officer of the company, and paid over to the inferior court, for the use of the poor of the county where such offence shall be committed.

Prince's Digest.
Approved December 8, 1806.
Slaves, Patrols and Free Persons of Color.

December 17, 1808

Whereas the permitting of free negroes and persons of Color to rove about the country in idleness and dissipation, has a dangerous tendency.

Sec. I. Be it enacted, That the justices of the peace with any freeholders of the district, be, any they are hereby vested with power to bind out to service, any male free negroes or persons of color over the age of eight years, until he arrives to the age of twenty-one years, to artisans or farmers: Provided such free person or persons of color have no guardian.

Sec. II The respective masters to whom such servants may be indentured, shall find them sufficient clothing to protect his or them from the inclemency of the weather, and sufficient boarding and lodging.

Sec. III. Where a complaint is made to the justices of the district where such indented servant may reside, of any ill usage by his said master, then and in that case, and investigation shall be had before the said justices; and on sufficient evidence being adduced, the said bounden servant shall be refused or released from such master, and placed again to service, to another person of the same trade or farming.

> Prince's Digest,
> December 17, 1808.
> Slaves, Patrols, and Free Persons of Color.

Decemeber 15, 1810

Slaves, Patrols, and Free Persons of Color.

Section VII. The judge of the superior or the justices of the inferior courts of the respective counties of this State, shall, upon the written application of any free negro or persons of color, made at any regular term of the said courts, praying that a white person resident of the county in which said application may be made, and in which such free person of color shall reside, may be appointed his or her guardian; and upon the consent in writing of such guardian, appoint such white person the guardian of such free person of color. And the said guardian

of such free negro or person of color, shall be, and is hereby vested with all the powers and authority of guardians for the management of the persons and estates of infants; and all suits necessary to be brought for or against such free person of color, shall be in the name of such guardian, in his capacity of guardian: Provided nevertheless, that the property of such guardian shall in no case be liable for the acts or debts of his wards.

Section VIII. The said judges of the superior or justices of the inferior courts, shall at their discretion require security from such guardian as may be appointed, for the proper management of the affairs of his ward. And such guardian shall be allowed the same compensation for the discharges of his duties as guardians of infants by the laws of this State.

Prince's Digest
Approved December 15, 1810.

December 12, 1815

An Act to compel Owners of old or infirm Slaves to maintain them.
Approved Dec. 12, 1815.

Sec. I. From and after the passing of this act, it shall be the duty of the inferior courts of the several counties in this State, on receiving information on oath of any infirm slave or slaves being in a suffering situation from the neglect of the owner or owners of such slave or slaves, to make particular inquiries into the situation of slave or slaves, and render such relief as they in their discretion may think proper.

Sec. II. The said courts may, and they are hereby authorized to sue and recover from the owner or owners of such slave or slaves, the amount that may be appropriated for the relief of such slave or slaves, in any court having jurisdiction of the same; any law usage, or custom to the contrary notwithstanding.

December 19, 1818

Act to alter and amend, "an act to prohibit slaves from selling" certain commodities therein mentioned.
Approved December 19, 1818.

Sec. II. If the party so charged fail to give sufficient security for his, her, or their personal appearance at the next superior court, to answer said charge, it shall then be the duty of the officer before whom such person or persons shall stand charged, to commit him, her, or them, to the common jail, in the county where the offence shall have been committed; and should there be no jail in that county, to the most safe and convenient jail in any of the adjacent counties, there to remain till the next superior court in the county where said offence is charged to have been committed, or until they shall give bail.

Sec. III. It shall be the duty of the attorney general or solicitors general, in their respective circuits, to cause the party or parties so recognized or held in custody for a violation of this act, to be indicted for the said offence, and on conviction, the court shall impose a fine of not more than five hundred dollars, with the cost of the prosecution; and imprisonment in the common jail of the county, or some other safe and convenient jail, for a period not longer than six months.

Sec. V. If any slave or slaves, or free persons of color, shall purchase or buy any of the aforesaid commodities from any slave or slaves, he, she, or they, on conviction thereof, before any justice of the peace, contrary to the true intent and meaning of this act, shall receive on his, her, or their backs, thirty-nine lashes, to be well laid on by any constable of said county, or other person appointed by the justice of the peace for that purpose: Provided nothing herein contained shall prevent any slave or slaves, from selling poultry at any time without a ticket, in the counties of Liberty, McIntosh, Camden, Glynn, and Wayne.

All the rest of this act is repealed by the penal Code.

December 24, 1821

An act to alter and amend the several Laws for the Trial of Slaves and Free Persons of Color in this State.

Passed 24th. December 1821.

Section I. From and after the passing of this act, the following be considered as capital offences, when committed by a slave or free person of color: insurrection, or an attempt to excite it; committing a rape or attempting it on a free white person or female; murder or a free white person; or murder of a slave or free person of color, or poisoning of a human being; every and each of these offences shall, on conviction, be punished with death; and the following shall also be considered as capital offences, when committed by a slave or free person of color: assaulting a free white person with intent to murder, or with a weapon likely to produce

death; maiming a free white person; burglary or arson of any description; also any attempt to poison a human being; every and each of these offences shall, on conviction, be punished with death, or such other punishment as the court, in their judgment, shall think most appropriate to the offence, and best promote the object of the law, and operate as a preventure for like offences.

Section II. Whenever a slave or free person of color is brought before the inferior court, to be tried for an offence deemed capital, it shall be the duty of said court to pass such sentence as may be pointed out by law, for the offence of which such slave or free person of color may be guilty; and in case a verdict of manslaughter shall be found by the jury, the punishment shall be by whipping, at the discretion of court, and branding on the cheek with a letter M.

December 23rd, 1833

An act concerning free persons of color, their guardians, and colored preachers.

Section III. It shall be unlawful for any person to give credit to any free person of color, but on a written order of the guardian.

Section IV. If neither the guardian nor the ward have property to pay any penalty which may be awarded under this act, or any debt which may be contracted under the written order of the guardian, it may be lawful for the court to bind out such ward, and upon such terms as they may think proper to satisfy such penalty or debt.

Section V. No person of color whether free or slave, shall be allowed to preach to exhort or join in any religious exercise, with any persons of color, either free or slave, there being more the seven persons of color present. They shall first obtain a written certificate from three ordained ministers of the gospel of their own order, in which certificate shall be set forth the good moral character of the applicant, his pious deportment, and his ability to teach the gospel, having a due respect to the character of those persons to whom he is to be licensed to preach, said ministers to be members of the conference, presbytery, synod, or association to which the churches belong in which said colored preachers may be licensed to preach, and also, the written permission of the justices of the inferior court of the county, and in counties in which the county town is incorporated, in addition thereto, the permission of the mayor, or chief officer or commissioners of such incorporation, such license not to be for a longer term than six months, and to be revocable at any time by the persons granting it...

December 26, 1835

An Act to be entitled An Act to prohibit the employment of Slaves and Free Persons of Color from compounding or dispensing of medicines in Druggists and Apothecaries to keep Arsenic and other dangerous poisons under lock and key.
Approved December 26, 1835.

Sec. I. From and after the first day of January next, and person or persons having in his, her or their employment any slave or free person of color in any apothecary shop in this State, in the apothecary branch of their business, in putting up, compounding or dispensing, purchasing or sending any drug or drugs, medicines or any description, kind or sort whatsoever, shall be guilty of a high misdemeanor, and on conviction thereof in any court having cognizance of the same, shall be fined the sum of one hundred dollars for the first offence, and for every subsequent offence shall be fined in the sum of five hundred dollars, one half of said fine to go to the informer, and the half into the county treasury for county purposes.

Sec. II. Every druggist or apothecary, or any other person or persons vending any medicines of a poisonous quality, shall not vend the same to any person or persons of color under the penalties aforesaid.

Sec. III. Nothing in this act shall be so construed as to prevent druggists and apothecaries from employing any negro or free person of color in that branch of their business which does not require them to open their drugs or medicines, or compound or dispense the same, but they may be permitted to employ said persons to perform the laborious part of their work under the immediate direction and control of some white person.

December 11, 1841

An act the better to secure and protect the citizens of Georgia in possession of their slaves.

Whereas, much inquiry has resulted to the people of Georgia in consequence of the abduction and unauthorized transportation of their slaves, by vessels sailing to ports without the limits of Georgia; and whereas, it is the duty of the General Assembly to guard against such injury in the most peaceful and constitutional manner; for remedy whereof -

Section I. Be it enacted by the Senate and House of Representatives of the State of Georgia, in General Assembly met, and it is hereby enacted by the authority of same, That from and after January first, eighteen hundred and forty two, it shall be the duty of all persons owning, chartering or acting as agents of any vessel or vessels trading or sailing from any of the ports within the limits of Georgia to any other port or ports not within the limits of Georgia, to give bond and security to the Justices of the Inferior Court of the Counties in which such ports may be, and as often as and whenever such vessel or vessels may depart from said ports, for the faithful observance, on the part of the captains, supercargoes, and crews of such vessel or vessels, of the right of property claimed and exercised by the citizens of Georgia over their slaves, and to insure and indemnify said citizens from any and all losses incurred in consequence of the abduction or escape of their slaves by such vessel or vessels, which security shall (to be given aforesaid) shall be residents within the State of Georgia.

Section II. And be it further enacted, That whenever any ship or other vessel shall ply as a packet or regular trader from any port within the limits of Georgia to any other port without said limits, then and in that case it shall be lawful for the owner, charterer, or agent, as the case may be, to give bond and security once annually, instead of giving of such bond at each departure of said ship.

December 11, 1841

An act to prohibit from sale, or gift, all printed or written books, papers, pamphlets, writing paper, ink, and all other articles of stationery of any kind whatever to any slave or free persons of color in this State; and to punish those who may violate the provisions of this act.

Section I. Be it enacted by the Senate and House of Representatives of the State of Georgia in General Assembly met, and it is hereby enacted by the authority of the same, That from and after the passing of this act, If any shopkeeper, store keeper, or any other person or persons whatsoever, shall sell to, give, barter, or in anywise furnish or allow to be furnished by any person in his, or her, or their employment, any slave, negro, or free person or color, any printed or written publication, writing paper, ink, or other articles or stationery, for his, her, their use, or for the purpose of sale without written or verbal permission from the owner, guardian, or other person authorized, such person or persons so offending, shall upon conviction thereof, pay a fine of not less than ten dollars nor more than fifty dollars for the first offence, and upon conviction for a second offence be subject to fine and imprisonment in the common jail

at the discretion of the Court, not to exceed sixty days imprisonment and five hundred dollars fine.

Section II. And be it enacted, That all laws and parts of laws militating against this act, be, and are hereby repealed.

> William B. Wofford,
> Speaker of the House of Representatives
> Robert M. Echols
> President of the Senate
> Assented to December 11, 1841
> Charles J. Mc. Donald, Governor.

December 27, 1845

An Act to prohibit colored mechanics and masons, being slaves or free persons of color being mechanics or masons, from making contracts for the erection of buildings, or for the repairs of buildings, and declaring the white person directly or indirectly contracting with or employing them, as well as the master employer, manager, or agent for said slave, or guardian of said free person of color, authorizing or permitting the same, guilty of a misdemeanor and prescribing punishment for violating this act.

Section I. Be it enacted by the Senate and House of Representatives of the State of Georgia in General Assembly met, That from and after the first day of February next, each and every white person who shall thereafter contract or bargain with any slave mechanic or mason, for the erection of any building, whether the same be done directly or indirectly with said slave mechanic or mason, or free person of color being a mechanic or mason shall be liable to be indicted for a misdemeanor, and on conviction to be fined at the discretion of the Court, not exceeding two hundred dollars – which fine when collected, shall be paid over to Inferior Court of the County in which the case was tried, for the uses of the county.

Section II. And be it further enacted, That the master of said slave mechanic or mason, or the employer, manager or agent for, or guardian of said free person of color, being a mechanic or mason, who shall knowingly authorize or permit, directly or indirectly, in contravention of the spirit and intention of this act, such slave mechanic or mason, of such free person of color being a mechanic or mason,

to make such contracts as are comtemplated in the first section of this act, shall be liable to indictment, in the court, for a misdemeanor and on conviction shall be punished by a fine at the discretion of the Court, not exceeding two hundred dollars, to be supplied, when collected, to county purposes as provided in the first section of this act.

Section III. And be it further enacted, That the judges of the Superior Courts do give this act in charge to the Grand Juries.

<div align="right">Approved December 27, 1845.</div>

January 17, 1850

An act to compel all persons taking up runaway slaves to deliver them to the jailor of the County where taken from and to prohibit said persons from detaining in their custody such runaway slave or slaves for a longer time than four days, and other purposes therein mentioned.

Section I. Be it enacted by the Senate and House of Representatives of the State of Georgia in General Assembly convened, and it is hereby enacted by the authority of the same, That from and immediately after the passage of this act, it shall be the duty of each and all persons in this State taking up any runaway slave or slaves, when the owner or owners of the same is or are unknown, to deliver the same to the jailor of the county where taken up within four days at least next after such taking up; provided, such slave shall not escape from custody; and that on failure or refusal so to do such person or persons so offending shall be guilty of a high misdemeanor, and upon indictment, trial and conviction therefor, shall be fined in a sum not exceeding fifty dollars or imprisoned in the common jail of the county for any time not exceeding three months, or both at the discretion of the Court; and the person so arresting and delivering to the jailor of any County any runaway slave or slaves shall be entitled to five dollars for each so delivered up and the same to be paid over to the jailor by the owner of said slave or slaves, his or her agent, when said slaves are delivered up, the same to be paid over to person so arresting and delivering up as aforesaid.

Section II. And be it further enacted, That all laws and parts of laws militating against this act, be and the same are hereby repealed.

<div align="right">Approved, February 22, 1850.</div>

March 5, 1856

An act to compel owners of the slaves on plantations or farms in Effingham County to keep a white man on said farm or plantation.

Section I. Be it enacted, etc., That from and after the passage of this act all, owners, trustees or agents of plantation or farms in the County of Effingham, whereon there are three or more grown slaves employed, and where such owner, trustee, or agent shall reside off and away from said plantation or farm, then it shall be the duty of such owner, trustee or agent to keep employed and statedly residing on such plantation or farm, a white man for the purpose of controlling and discipling said slaves, and in default of said owner, trustee or agent employing and keeping statedly residing on such plantation or farm a white man for a longer period than sixty days at any one time said owner, trustee or agent shall be deemed and held guilty of a misdemeanor, and on conviction thereof before the Superior Court, shall be fined or imprisoned at the discretion of the court.

Section II. Repeals conflicting laws.

December 17, 1859

An Act to prevent free persons of color, commonly known as free negroes from being brought or coming into the state of Georgia.

Section I. Be it enacted etc., that from and after the passage of this Act it shall not be legal for any free person of color commonly known as negroes, now residing or who shall reside after the passage of this act in any State of this Confederacy or foreign Country to come or to be brought into this state, and any and all free persons of color who shall come or be brought into this State, after the passage of this Act in All violation thereof shall on conviction of said violation be sold as a slave or slaves by the Sheriff of the County in which said conviction shall be made.

Said Sheriff is hereby Authorized to make titles to the purchaser or purchasers of the same – the net proceeds of such sale shall be paid one half to the informer the other half to county purposes And the persons bringing such free persons shall be guilty of a high misdemeanor; And on indictment of the same and on conviction thereof shall be fined in a sum not less than one thousand dollars and imprisoned in the jail of the county in which such indictment shall or may be preferred not less than twelve months provided, however, that if any free person

or persons of color shall be brought or come into this State, within, six months after the passage of this Act, such persons shall not be subject to the pains and penalties of the same until after thirty days notice shall have been given.

Section II. Be it further enacted that the Superior Courts of the several counties of the state shall have Jurisdiction of the several offences created or mentioned by this Act.

December 5, 1863

An Act to Add certain sections to the Penal Code of Georgia.

Section II. Be it further enacted, that any slave or free person of color, who shall go to the enemy, with the intention of giving them information of any kind shall on conviction of the same suffer such punishment as the Court trying said offence may in its discretion inflict not extending to life or limb or as the jury may recommend by the verdict.

Section III. Be it further enacted, that any slave who shall leave the service of his owner or employer And go over to the enemy, or shall leave the service of his owner or employer with the intention of going over to the enemy; or shall attempt to leave the service of his owner or employer for the purpose of going over to the enemy shall on conviction of the same suffer such punishment as the Court trying said offence may inflict in its discretion, not extending to life or limb or as the Jury may recommend by their verdict provided that this Act shall not apply to a slave who voluntarily and bonafide returns to the service of his or her owner or employer.

Section IV. Be it further enacted, that any slave or free person of Color, who shall, by promises of freedom or liberty, or by Any kind of incitement entice or induce any slave to leave the service of his master or shall attempt to induce or entice said slaves, shall on conviction, thereof, suffer the punishments of death or such other punishment as the Jury may recommend in their verdict, and in case of no such recommendation, such punishment as the Judge presiding in his discretion may inflict.

Section V. Repeals conflicting laws.

December 13, 1866

An Act to legalize marriages by colored ordained ministers of the gospel and also to authorize such colored ministers of African descent, to solemnize future marriages between freedmen and freedwomen of African descent only.

Section 1. Be it enacted etc., That all marriages heretofore celebrated by ordained colored ministers of the gospel, or ministers of the African descent, between freedmen and freedwomen and persons of African descent, shall, and the same are hereby declared to be legal an valid to all intents and purposes.

Section 2. That it shall and is hereby made lawful for ordained, colored ministers of the gospel, of African descent, to celebrate marriages between freedmen and freedwomen, or persons of African descent only, under the same terms and regulations as are now required by the laws of this State for marriages between free white citizens of this State.

Section 3. Repeals conflicting laws.

March 17, 1866

An act to define the term, "persons of color," and to declare the rights of such persons.

Part 1. Sec. 1. The General Assembly of the State of Georgia do enact, That all negroes, mulattoes, mestizoes, and their descendants, having 1/8 negro or African blood in their veins, shall be known in this State as, "person of color."

Sec. 2. That persons of color shall have the right to make and enforce contracts, to sue and be sued; to be parties and give evidence to inherit, purchase, lease, sell, hold and convey, real and personal property, and to have full and equal benefit of all laws and proceedings, for the security of persons and estate and shall not be subjected to any other or different punishment, pain or penalty for the commission of an act or offense, than such as all prescribed for white persons, committing like acts or offences.

Sec. 3. That all laws and parts of laws in relation to slaves, and free persons of color militating against this Act, be, and the same are hereby repealed.

March 9, 1866

An act to prescribe and regulate the relation of husband and wife between persons of color.

Sec. 1. The General Assembly of the State of Ga., do enact, That persons of color, now living together as husband and wife, and hereby declared to sustain that legal relation to each other, unless a man shall have two or more reputed wives or a woman two or more reputed husbands. In such event, the man, immediately after the passage of this act by the General Assembly, shall select one of his reputed wives with her consent; of the woman, one of her reputed husbands with his consent, and the ceremony of marriage between these two shall be performed. If such man, thus living with more than one man shall fail or refuse, to comply with the provision of this section, he or she shall be prosecuted for the offence of fornication, or fornication or adultery, or, fornication and adultery, and punished accordingly.

Approved 9th of March 1866.

October 10, 1891

An act to make it unlawful for white and colored convicts be confined together or work chained together, and to provide a penalty for the violation thereof.

Section I. Be it enacted by the General Assembly and it is hereby enacted by the authority of the same, That from and after the passage of this Act it shall be unlawful for any person or firm leasing or controlling any convicts in this State to confine white and colored convicts together, or to work them chained together, nor shall they be chained together going to or from their work or at any other time.

Section II. Be it further enacted by the authority aforesaid, That any person, and each member of any firm of persons violating the provisions of this Act, shall be guilty of a misdemeanor and on conviction shall be punished as provided in Section 4310 of the Code of Ga. of 1882.

Section III. Be it further enacted by the authority aforesaid, That all laws or parts of laws in conflict with this Act be, and the same are hereby repealed.

Approved October 10, 1891.

October 10, 1868

An Act for the raising a revenue for the latter half of the political year Eighteen Hundred, and Sixty-Eight, and to appropriate money for the support of the Government during said half year, and to make certain special appropriations, and for other purposes herein mentioned.

Section I. Be it enacted, that the representatives and senators, those from the first district excepted, occupying seats lately vacated by the colored persons, receive pay from the time, seats by colored persons were taken.

December 20, 1899

An Act to require companies and railroad companies operating sleeping cars in this state to separate white and colored passengers: to extend the police powers of Conductors of the train to which sleeping cars are attached; to prescribe certain penalties and for other purposes.

Section I. Be it enacted by the General Assembly of the State of Ga., that from and after the passage of this Act sleeping car companies and railroad companies operating sleeping cars in the State shall have the right to assign all passengers to seats and berths under their charge and shall separate the white and colored races in making said assignments and the conductor and other employees on the train of cars to which said sleeping car or cars maybe attached, shall not permit white and colored passengers to occupy the same apartments. And any passenger remaining in any apartment other than to which he may be assigned, shall be guilty of and punished for a misdemeanor, provide that nothing in this Act shall be construed to compel sleeping car companies or railroads operating sleeping cars to carry person of color in sleeping or parlor cars, provided, that this Act shall not apply to colored nurses or servants traveling with their employers.

Section II. Be it further enacted by the General Assembly that any conductor or other employee of any sleeping car as well as any conductor of other employee of the train to which any sleeping car may be attached, are hereby empowered with full police power to enforce the preceeding section and any conductor or other employee of any sleeping car, or of any train carrying sleeping cars.

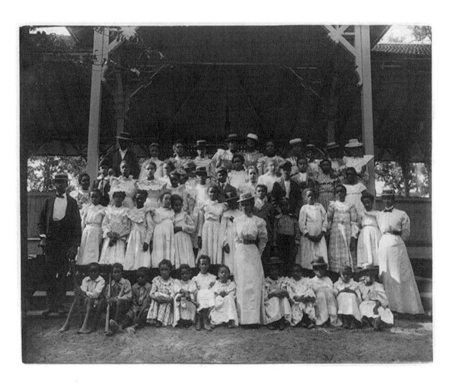

African-American children and adults in a pavilion. In album (disbound): Negro Life in Georgia, U.S.A., compiled and prepared by W. E. B. Du Bois, v. 3, no. 282.

Afterword

In 1893, African-Americans were denied the opportunity to formally participate in the Chicago World's Columbian Exposition. In 1895, Booker T. Washington gave his most important speech on race relations at the Atlanta Exposition—a much smaller venue than the Chicago fair, but nonetheless an important precedent. Thomas Calloway obtained funds from the United States government for the Exhibit of American Negroes at the *1900 Paris Exposition Universelle*. Drawing primarily on the insight and energy of W. E. B. Du Bois, a collection of photographs, sociological charts, books, research reports, and physical objects were assembled to create a data set, or "archive," on the condition of Black life and culture in the United States. The Exhibit recorded the lives of seven million people brought together by their common heritage of African origin, slavery and oppression—a group referred to by Du Bois as "a small nation of people."

As eloquently pointed out by Shawn Michelle Smith, the Exhibit of American Negroes provided Du Bois the means by which to redefine the meaning of Race in the United States. Du Bois did this by utilizing "the tools of visual representation both to problematize racist propaganda and to envision a New Negro" at the turn of the century.[1] Du Bois was aided in this effort not only by Calloway, but by many now anonymous, or at least forgotten, contributors to the exhibit. Exceptions to this are Daniel A. P. Murray, from the Library of Congress, whose bibliography and collection of books by American Black authors contradicted the notion that African-American life was not, or could not be, vibrant, alive, and productive. In a more limited way, the photographs of the white female photographer Frances Benjamin Johnston illustrated how the "New Negro" was also becoming a reality.

What Du Bois accomplished through the Exhibit as a photographic and social "archivist" was remarkable. As Shawn Michelle Smith explains:

> As archivist, Du Bois has constructed an archive he would appear to stand outside of; he has exercised the power of a disembodied gaze, turning his scrutiny, and ours as viewers, on the faces of hundreds of nameless others, while he himself makes his presence felt only abstractly. At precisely this historical moment, however, an African American public was just beginning to call on Du Bois to be "representative;" he was just beginning, and indeed fighting, to bear the burden of an exemplary status, both a rare privilege and an impossible restraint.[2]

Essentially, the Exhibit of American Negroes presented a counter-narrative to the racial stereotypes and misconceptions that so dominated American and even international culture at the beginning of the twentieth century. The exhibit contradicted Booker T. Washington's concept of African-Americans being

"separated like the fingers on a hand" from White society. Instead, its photographs, books, charts, and reports demonstrated that the Negro, or Black, was in fact uniquely American.

I believe it is in this context that the Exhibit is best understood—essentially, as a living and vital archive of the complex lives and diversity of African-Americans at the beginning of the twentieth century. I write these words 110 years after the exhibit closed, and over thirty years after I first discovered these materials at the Library of Congress. I consider myself privileged as an historian of education, culture and race to have had the opportunity to discover, explore, and try to understand this "small nation of people" at a formative and defining point in their history.

NOTES

1. Shawn Michelle Smith, *Photography on the Color Line: W. E. B. Du Bois, Race, and Visual Culture* (Durham and London: Duke University Press, 2004). p. 148.

2. Ibid., p. 149.

BIBLIOGRAPHY

Aptheker, Herbert. *Annotated Bibliography of the Published Writings of W. E. B. Du Bois*. Millwood, N.Y.: Kraus-Thomason Organization, 1973.

Broderick, Francis. *W. E. B. Du Bois, Negro Leader in a Time of Crisis*. Palo Alto, C.A.: Stanford University Press, 1959.

Brown, Robert W. *"Paris 1900," in the Historical Dictionary of World's Fairs and Expositions, 1851-1988*, John E. Findling annd Kimberly D. Pelle, editors. New York: Greenwood Press, 1990.

Du Bois, W. E. B. *The Suppression of the African Slave Trade in the United States of America*, 1638-1870. Harvard Historical Studies Number 1(1896).

————, editor. *Some Efforts of American Negroes for Their Own Social Betterment.* Atlanta, G.A.: Atlanta University Press, 1898.

————. *Some Efforts of American Negroes for Their Own Social Betterment*. Atlanta, G.A.: Atlanta University Press, 1898.

————. "The Conservation of the Races," *American Negro Academy, Occasional Papers*, No. 2, 1897, reprinted in W. E. B. Du Bois, *Writings* (New York: The Library of America, 1986), p. 820.

————. *The Philadelphia Negro*. New York: Oxford University Press, 2007. Introduction by Lawrence Bobo. Originally published in 1899.

————. "The American Negro at Paris," *The American Monthly Review of Reviews*, vol. XXII, (November 1900), p. 577. no. 5.

————. *Du Bois: Writings*. New York: The Library of America, 1986.

————. *Dusk of Dawn: An Essay Toward and Autobiography of a Race Concept*, introduction by Irene Diggs. New Brunswick, N.J.: Transaction Books, 1984, first published in 1940.

————. *The Autobiography of W. E. B. Du Bois: A Soliloquy on Viewing My Life from the Last Decade of Its First Century*. New York: International Publishers, 1968.

————. *The Correspondence of W. E. B. Du Bois*. Amherst: University of Massachusetts Press, 1973-78. 2 Volumes. Herbert Aptheker, editor.

————, editor. *The Negro American Family*. Atlanta, G.A.: The Atlanta University Press, 1908.

Fischer, Diane P., editor. *Paris 1900: The American School at the Universal Exposition*. New Brunswick, N.J.: Rutgers University Press, 1999.

Green, Dan S. and Driver, Edwin D., editors. *W. E. B. Du Bois: On Sociology and the Black Community*. Chicago: The University of Chicago Press, 1978.

Hamilton, Virginia. *Black Titan: W. E. B. Du Bois*. Boston: Beacon Press, 1970.

————. *W. E. B. Du Bois*. New York: T. Y. Crowell, 1972.

Lewis, David Levering. *W. E. B. Du Bois: Biography of a Race*. New York: Henry Holt and Company, 1993.

Lewis, David Levering. *W. E. B. Du Bois: The Fight for Equality and the American Century 1919-1963*. New York: Henry Holt & Company, 2000.

Mandell, Richard D. *Paris 1900: The Great World's Fair*. Toronto: University of Toronto Press, 1967.

Marable, Manning. *W. E. B. Du Bois: Black Radical Democrat*. Boston: Twayne, 1986.

Murray, Daniel. *Preliminary List of Books and Pamphlet's by Negro Authors for the Paris Exposition and Library of Congress* Washington, D.C.: Library of Congress, 1900.

Museum of Modern Art. The Hampton Album: *44 photographs by Frances B. Johnston from an Album of Hampton Institute*, with an introduction and note on the photographer by Lincoln Kirstein (New York: The Museum of Modern Art, 1966).

Provenzo, Eugene F., Jr., editor, *Du Bois on Education*. Walnut Creek, CA: Altamira Press, 2002.

————, editor. *W. E. B. Du Bois: The Illustrated Souls of Black Folk*. Boulder, Colorado: Paradigm Press Press, 2005.

Travis, Miles Everett. *Mixed Message: Thomas Calloway and the "American Negro Exhibit" of 1900*. Bozeman, Montana: Montana State University, April 2004. Masters thesis, Montana State University.

Rudwick, Elliott. *W. E. B. Du Bois: A Study in Minority Group Leadership.* Philadelphia: University of Pennsylvania Press, 1960.

———. *W. E. B. Du Bois.* New York: Atheneum, 1968.

Shaw, Albert. "Learning by Doing' at Hampton." *The American Monthly Review of Reviews*, April 1900, pp. 417-432.

Smith, Shawn Michelle. *Photography on the Color Line: W. E. B. Du Bois, Race, and Visual Culture.* Durham and London: Duke University Press, 2004.

United States Census, Department of Commerce and Labor's Bulletin #8. *Negroes in the United States.* Washington: Government Printing Office, 1904.

Washington, Booker T. "Atlanta Compromise" Speech (September 18, 1895), included in the Facts On File, Inc. CD-ROM, *African-American History and Culture.* New York, 1999.

Zuckerman, Phil, editor. *Du Bois on Religion.* Walnut Creek, C.A.: Altamira Press, 2000.